W9-BMD-417

PHOTOGRAPHING
Architecture

Lighting, Composition, Postproduction, and Marketing Techniques

John Siskin

AMHERST MEDIA, INC. ■ BUFFALO, NY

DEDICATION

This book is dedicated to my father, Sheldon Siskin. He taught me to ski and surf and how to live on planet Earth. He got me my first camera and my first job in photography. Thanks, Dad. I love you!

Copyright © 2012 by John Siskin.
All photographs by the author unless otherwise noted.
All rights reserved.

Published by:
Amherst Media, Inc.
P.O. Box 586
Buffalo, N.Y. 14226
Fax: 716-874-4508
www.AmherstMedia.com

Publisher: Craig Alesse
Senior Editor/Production Manager: Michelle Perkins
Assistant Editor: Barbara A. Lynch-Johnt
Editorial assistance provided by John S. Loder.

ISBN-13: 978-1-60895-300-4
Library of Congress Control Number: 2011904397
Printed in the United States of America.
10 9 8 7 6 5 4 3 2 1

No part of this publication may be reproduced, stored, or transmitted in any form or by any means, electronic, mechanical, photocopied, recorded or otherwise, without prior written consent from the publisher.

Notice of Disclaimer: The information contained in this book is based on the author's experience and opinions. The author and publisher will not be held liable for the use or misuse of the information in this book.

Check out Amherst Media's blogs at: http://portrait-photographer.blogspot.com/
http://weddingphotographer-amherstmedia.blogspot.com/

Contents

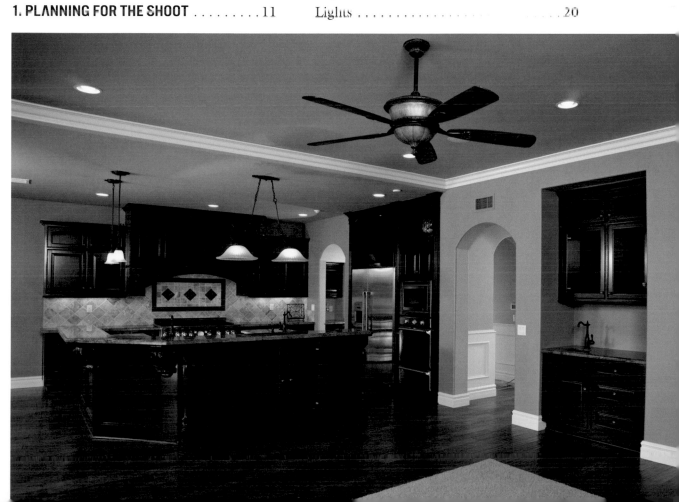

About the Author

John Siskin is a fine art and commercial photographer who often works with landscape and architectural images. He has done a large number of commercial jobs, including projects for General Motors, Disney, and AidsWalk. His portraits for AidsWalk have been displayed on the streets of Los Angeles, Atlanta, San Francisco, and New York City. He has taught photography for more than twenty years at colleges in Southern California and is currently teaching classes online at BetterPhoto.com.

John's work has been part of many exhibits. His photographs have been shown at the Brand Library, 2nd City Art Gallery, Harold's Gallery, Farmani Gallery, and The Atelier. He has been a regular participant in the Valley Studio Tour.

John's first book, *Understanding and Controlling Strobe Lighting: A Guide for Digital Photographers,* was published by Amherst Media in 2011. His work has also appeared in a number of magazines, including *View Camera, Photo Technique, The New Yorker,* and *Shutterbug.*

More of John's work, and some of his magazine articles, can be seen at www.siskinphoto.com.

ACKNOWLEDGMENTS

This book wouldn't exist without the help of some truly wonderful people. First, my wife Susan Siskin, who has been endlessly supportive throughout this project. Thank you! Second, Tom Ferguson. Tom is the first, and sometimes only, person who reads my words before they go to the publisher. I wouldn't have the confidence to do this without him. All the mistakes are mine; the fact that there aren't more is because of Tom.

This book is also a product of the clients I've worked for. Without them, I wouldn't have taken most of these images. There's one client I want to single out: Terry Beeler and Son General Contractor, Inc. They do awesome work, and I get to photograph it. If you're in Southern California and need to build a house or other building, call them at (661) 251-8435 or visit them online at www.beelerbuildsembetter.com. You can see thousands of my images there.

Finally, I want to thank Lance Gullickson. He has assisted me on many of the jobs that appear in this book, and he took the pictures of me that appear herein.

I would also like to thank the following for their help and lifestyle advice: Harlan Goldberg, Terry Pobirs, Jennifer Halsworth, Bob Cole, David Beeler, Maureen Levitt, Gretchen Haacker, Rico Mandel, Lem Johnson, Cris Pendarvis, Big Wave Dave, Melanie Zimmerman, Matt Ehrenberg, Dodie, and C.J.

The Essentials

Architectural photography is typically client-driven. In other words, you are hired by an individual or business—be it an interior decorator, a builder, or a hotelier—who needs images of their space. To do the job effectively, you must master the technical and artistic aspects of the job—learning how to select and use the appropriate tools, solving problems, and fine-tuning the image. You must also handle the business aspects of the shoot—finding clients, writing a proposal, providing an estimate, etc.

The chapters in this section are devoted to the nuts and bolts of the business, from analyzing the room to finding and communicating with clients, to choosing the right gear, placing and modifying the light, and retouching/finessing the images in postproduction.

Introduction

THE IMPORTANCE OF ARCHITECTURAL PHOTOGRAPHY

Most people live the majority of their lives in buildings. We start life in a hospital, and then we go home. We spend our days in offices, factories, and shops. A home is the most expensive thing that most families ever own. Buildings are important to people. There may be a science fiction story about technically sophisticated beings that live outside, but you'll find humans indoors. Our buildings are so important to us that we refer to them as *buildings* rather than *builts*. They are

BELOW—A cathedral in England. Buildings like this were often made over decades.

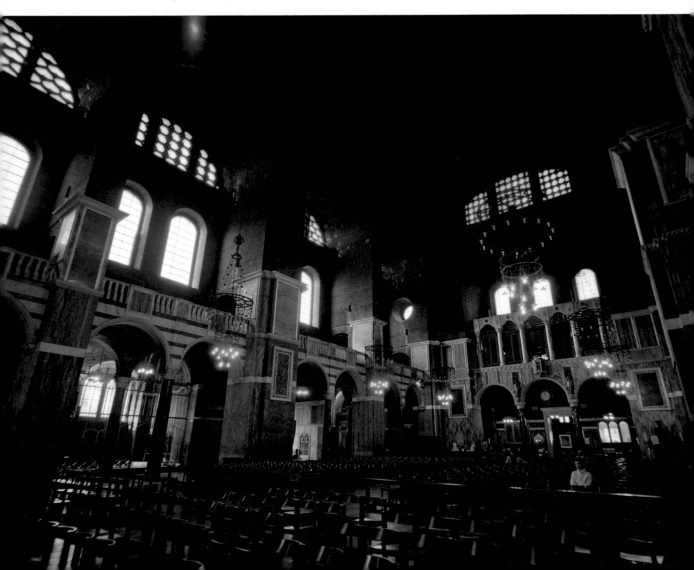

ongoing creations. People have been constructing buildings for thousands of years, and often they are our most lasting creations.

Making photographs of buildings is very important to photographers and to a lot of other people. We may take photographs of people working on a building, or a person working inside, or a photograph of the building. We may be taking photographs for a wedding, or we may take photographs for a contractor. Regardless, we will need to make the location part of the photograph, or it may be the whole shot.

Photographing interiors requires a specialized approach. There are many decisions that must be made before, during, and after the shoot that do not come into play when photographing most other subjects.

This book was written to teach you the skills you need to meet the challenges that photographing architecture presents, so that you can provide your clients with polished, high-quality images they can use to showcase their businesses.

WHY INTERIORS?

A photographer needs a variety of skills to be good at architectural photography. We need some of the same skills to shoot the exterior of a building that we'll need to shoot inside of it. We'll need more skills and also different tools to shoot inside. So, an interior shot requires lights, a tripod, and a wide-angle lens to do well. When you shoot outdoors, you don't have as much control over light. Often, the only thing you can do is be patient. For interiors and exteriors, a good sense of design, angle, and attention to detail will make you a better photographer.

Most of this book is concerned with shooting interiors, because the skills involved are

Top—A plastic surgeon's office in Beverly Hills, California. Bottom—Balancing the light from the strobes with the window light in this image was difficult, but it worked out well.

complex. Learning to use lights effectively may require considerable attention and practice. The technical skills required can be transmitted via the pages of a book. In contrast, when it comes to shooting exteriors, I am not sure that I can teach you to wait patiently for a cloud to pass or dawn to come. Still, there is one thing I should say about photographing a building at dawn: dress warmly!

USING THIS BOOK

This book was created to help you understand how to build better images. It was written in two parts: in Part One, you'll find chapters devoted to finding and communicating with clients; selecting the proper equipment for the job; choosing the most effective camera position; placing lights, controlling light, ensuring proper lighting balance; and correcting the perspective issues that are prevalent in architectural photography.

I've also included information on how to fix problems in postproduction. Layers and other Photoshop features will help you to bring out the best qualities in any photograph. I'll explain how to work with Layers and teach you how to create High Dynamic Range (HDR) captures. HDRs are especially effective for situations where you don't have lights or can't light a location due to its size or other considerations.

In Part Two, I've provided a look at how I made selected images—from start to finish. I've discussed how the shot was done, what the problems of getting the shot were, and all the work that was done in Photoshop after the shot. I've included examples of homes, businesses, and public spaces in this section.

So, here it is: a book that can help you shoot buildings—from start to finish. Let's get started.

1. Planning for the Shoot

ANALYZING THE ROOM

Before you begin the shoot, it is important to take some time to analyze the space. What is your first impression of the room? For some, it will be color. Some will see the space. Others will be impressed by the room's contents. When you photograph a room, you effectively miniaturize it, so you need to pay attention to the original feel of a space or you'll lose the effect in the photograph. Architectural photography requires a great sensitivity to the feel of a place, in addition to an appreciation for the finer points. The details of the room—the physical space, the design and color of the existing light, the textures, and the decor—should be taken into consideration. You'll also need to determine how the client sees the room.

The Shooting Angle. Before you fully conceptualize your shot, walk all the way around the room. Don't assume that the entrance is the only good angle from which to take the shot. You'll also want to consider the point of view. A five-foot-tall photographer sees differently than a photographer who is six feet tall. The best angle might be from two feet or seven feet from the ground. Sometimes I wish I had stilts! When you choose a tripod, you should keep this in mind. You'll find more information on choosing the appropriate shooting angle in chapter 4.

ABOVE—This is a simple shot, but the light makes it work well. One strobe was used with a large umbrella.

LEFT—This shot advertised a winery. The goal was a lifestyle image.

the room. If you change the lighting radically, people may feel you haven't properly captured the room. When you consider your shooting options, you'll want to know how the room is lit and how the movement of the sun will affect the overall lighting at the time of the shoot—and your lighting strategy should be built around the qualities of the existing light you find.

Indoor scenes have a wider tonal range than outdoor scenes do, and capturing them requires adding more light or working a little magic in postproduction (more on this later). When you add light, it often has a different color temperature than the existing light does, and you must find a way to balance the lighting. Later in this book, there are tips and techniques for creating harmonious lighting while upholding the mood that the lighting creates.

IMAGE USAGE

Another important point to consider before you begin to shoot is how the final image will be used and the size at which it will be viewed. Some of the aspects of the room may "read" better in a larger image shot for a two-page spread in a magazine than in a small image destined for your client's web site. Also, the amount of postproduction work that is required, and even the amount that you will bill your client, will depend upon the final image usage. After all, creating a web image doesn't require as much work as preparing an image for print.

Chapter 7 is devoted to the topic of working with clients. So, beginning on page 77, you'll read about a wide range of client-related topics—from identifying prospective clients to

The Key Players. Look at the furnishings in the room. Often, I have to repeatedly reposition a piece of furniture to get it to feel right. Keep in mind that anything that is near the edge of the frame is more likely to appear misshapen than an object in the center of the shot. So if an object is important to the shot, like a piece of exercise equipment in a gym, don't put it at the edge.

Sometimes, distortion issues must be solved by changing our perspective, using tilt/shift lenses, or manipulating the image in Photoshop (this is often the most effective option). You'll learn how this is done in forthcoming chapters.

The Existing Light. When looking at a room, it is important to pay attention to the existing light. The lighting in the room is part of its design, and it establishes how everyone sees

communicating your expectations and requirements and more. As these client-related topics come into play when planning for your shoot, though, it seemed important to touch on the importance of communicating with your clients here.

IN SUMMARY

A successful shoot requires a well-thought-out and clearly defined approach. Before you select your tools or place a single light, analyze the room and consult with your client to determine whether you are both on the same page regarding the mood the image should convey. Also, be sure you understand how the image will be used and what its final size should be. These are critical aspects of planning the image.

Once you've accomplished these tasks, you're ready to dig in and get to work.

Left—You can see how the basin is elongated in this shot. Shapes, especially near the edge of the frame, can get distorted. Right—The client wanted to keep the ottoman and the basket in the shot. Clients get to make the decisions!

2. Choosing the Right Gear

When you shoot architectural interiors, the first thing most clients request is a very wide angle shot. All clients initially want too much space covered in a single shot. While this is not always a good idea for communicating anything about the actual character of a space, you will need to be able to do this. So, the first concern in picking a camera are the wide angle lenses available for that camera. Rather than discuss a specific focal length, because that is dependant on the size of the sensor or film, let's talk about the angle of coverage.

CAMERAS

I won't say that the camera doesn't matter, but it is the lens that makes the picture. So if you get a good camera and use the lens included in a camera kit, you probably won't make good architectural photos. As I mention below, you'll need to capture a very wide angle of view, which requires specialized lenses. Many dSLR cameras, but not all, have lenses that do this very well.

The camera you choose must also work with monolight strobes, not just dedicated strobes. It is nice to have a PC socket that will connect to strobes, but you can also connect via most hot shoes. Many fixed-lens cameras won't be wide enough, nor will they connect to strobes. There may be some advantage in using a dSLR camera

that captures the full area of 35mm film frame. However, as there are more and more very wide lenses manufactured for use with the smaller sensors, any advantage is limited.

You will want to capture a high number of pixels—at least 10 megapixels, but more would be better. There are medium format digital cameras that take wide lenses, but they are rather expensive. Unless your clients need very large prints, more than 16x20 inches, an investment in a medium format camera may not improve your images, even though it will be costly. Some of the images in this book were done with large format film cameras that used a piece of 4x5-inch film. Certainly this could still be done, but there would be problems with processing and previewing the image. I used to use a lot of Polaroid instant material to set up the images with my big camera, and this added a lot of expense. So I think that a good dSLR, probably from Canon or Nikon because they make more types of lenses, will be best for most people shooting architecture.

LENSES AND ANGLE OF VIEW

On a full-frame sensor, which is about 1x1.5 inches, a 20mm lens covers a 94 degree angle of view. This is about a quarter of a circle. If you were using an APS-size sensor, you would need a focal length of about 12mm to accomplish the

Above—This is a shot made with my widest lens, which captures an angle of view of about 100 degrees from side to side. Still, there are times when my clients would like an even wider image.

same angle of view. If you used a 4x5 film camera, you would need a 75mm lens to achieve that angle of view. I commonly use a lens with a 100 degree angle of view, and I would occasionally like a wider angle. Of course, a zoom is very useful because it allows you to crop the image and do a better job of choosing your position. However, a zoom (a lens with a variable focal length) is not as important as how wide the angle of view is. So a lens that has a 100 degree angle of view is better than a lens with a 90 degree angle of view, even if the second lens can change the angle of view to just 75 degrees. You can crop the image, but you'd have trouble making it wider.

The longest lens I have ever used for an interior shot has an angle of view of about 50 degrees. This is called a normal lens. This lens is not very useful for photographing a room, but it can work well for shooting architectural details. In addition, these are generally fast lenses (f/1.8 or faster), so they can be useful for shooting with ambient light. A more telephoto lens might occasionally be useful for shooting an exterior shot of a location.

Wide angle lenses all have certain peculiarities that are often interpreted, wrongly, as distortion. Probably the most obvious of these issues is keystoning. This term describes the way that parallel lines seem to come together as they recede from the camera. If you look at a train track going away from you, the same thing happens. Because a wide angle lens expands the view quickly, this effect is pronounced. If the camera is parallel to the subject, the image will appear natural, just as the train tracks would from directly above. However, the subject will appear increasingly

Choosing the Right Gear 15

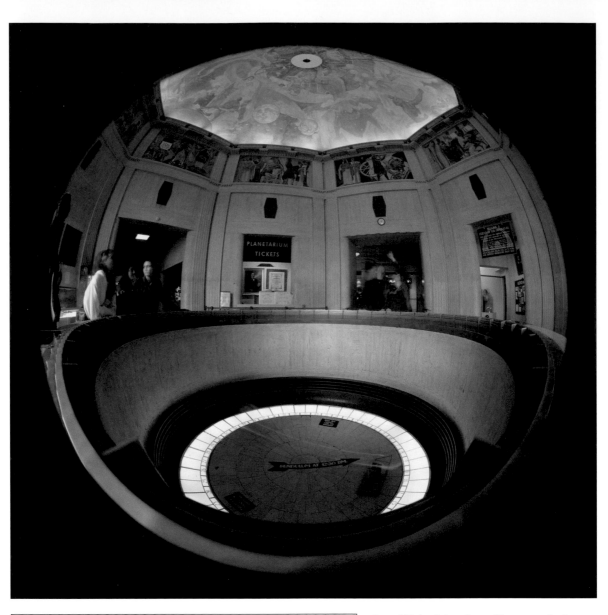

ABOVE—This is a fisheye image. The camera shoots everything in front of the camera. Often the tripod legs are in the shot. LEFT—I custom made this fisheye camera, comprised of a Speed Graphic camera and a Ukrainian lens. It was one of my favorite film cameras.

distorted if the camera is pointed up or down. This effect can be adjusted in Photoshop and some other image-editing programs.

Using a wide angle lens can also change the shape of an object at the edge of the frame. A circular object can appear oval and a square can look like a trapezoid. Often this problem can be adjusted after the shoot, but it is best to be aware of it at and make adjustments in the placement of objects while shooting. Note that this distortion is caused by standing very close to the subject while using a wide angle lens; it is not a fault of the lens itself. This effect is not as important in landscape photographs. You also don't see the effect if you back up far enough to use a normal lens. But, of course, we can't always do that.

There are two distortions that result simply as a characteristic of wide angle lenses. The first is barrel distortion. This causes straight lines to bow outward, particularly at the edges of the frame. There are lenses that are corrected for this problem, but some of mine are not well corrected. Fortunately, this can be fixed in Photoshop.

There are some lenses, called fisheye lenses, that use a sort of extreme barrel distortion to add more coverage. Often these lenses will have coverage of 180 degrees—this is everything in front of the camera! Because they make any straight line curve, and straight lines at the edge of the frame are actually circular, there is little use for these lenses commercially. They offer a unique view, and they are a lot of fun. Also I have had a few commercial clients who liked the look. I have a unique fisheye camera that shoots 4x5 film, but few of these cameras were made.

Some wide angle lenses produce color fringing. This appears as a sort of a color halo around the edges of objects positioned near the edges of the frame. This problem can be edited out in postproduction.

As all of the problems outlined above can be solved in postproducion (or, in the case of the shape distortions, during the shoot), there is no reason to avoid using a wide angle lens to get the angle your clients are after.

You can also take multiple images and stitch them together in postproduction. This can make a shot that is wider than the lens will allow in one image. I prefer not to do this. Unless you use a normal lens, there will be a lot of trouble with the way objects are distorted at the edge of the frame, and this won't match from shot to shot. So you can end up spending a long time fixing the image. This is not as much of a problem with a wide landscape shot because there is less important detail and you are much farther from

BELOW—I stitched this landscape image from several frames. Stitching works better for landscape photography than for interiors.

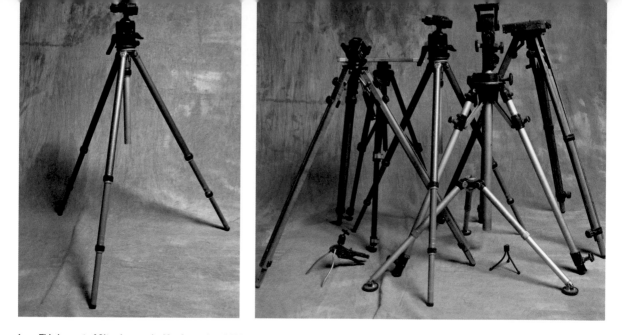

Left—This is a set of Gitzo legs and a Manfrotto head. This is the tripod I use most often with my dSLR camera. Right—I have a lot of tripods. They are useful for getting into tight places or supporting heavy cameras. I use the small tripods as light stands as often as I use them for cameras.

the subject. The distance from the subject, as I mentioned, affects the distortion at the edge of the frame.

TRIPODS

When you do interior shots, the tripod is a very important tool. First, it gives you an opportunity to pay real attention to the way you compose your image. Second, it allows you to use long exposures so that the ambient light in a shot can be balanced to match the light you bring and also allows you to have enough depth of field. You get more depth of field by using an aperture setting that lets less light into your camera. F/16 gives you much more depth of field than f/4. I often use f/8 or f/11 when shooting architecture with my dSLR. Lastly, the tripod keeps your camera in position as you go about changing the setting and positions of your lights.

You want to get a very sturdy tripod that will keep your camera in *precisely* the same position.

As we'll discuss later, there are times when you want to make multiple captures of an image. You'll use these to perfect the image in postproduction. Having a stable tripod is much more important than having a lightweight one. Shooting interiors is not a lightweight proposition, so the weight you can save with a light tripod won't make much difference. Set up your camera on your current tripod and see how much of a tap it takes to move it out of position. You might want to look at tripods in a good camera store and see if you can find something really stable. It is easier to choose a good tripod in person than shopping on the net. Keep in mind that the spikes that many tripods have cannot be used in most interior locations.

Many tripod manufacturers sell tripod heads (the part that positions the camera) separately from the legs. This is a really good thing, as it allows you to customize the tripod to your way of working. When I used a large view camera,

I used a geared tripod head because it made it much easier to precisely position the heavy camera. A geared head allows you to adjust the position by turning a crank or a wheel that slowly moves the camera. While it is slower, it doesn't slip out of position with a heavy camera. When I use my dSLR, I use a ball head, which allows the camera to move in all directions at the same time. The ball head clamps down with a single lever. I like to work with a ball head, as it allows me to position the camera as needed quickly and easily. I know other photographers who prefer pan/tilt heads, which they feel give them more precision. A pan-tilt head has a separate release for horizontal, tilt, and vertical movements. It is possible to move the camera in only one direction at a time. The problem, for me, is that I need to remember to clamp down the head in three places.

Your tripod is one place where it doesn't make sense to economize. Tripods last for decades and never become outdated. I have tripods that are more than fifty years old and still work well. Carbon fiber is currently popular because of weight, but I have very fine tripods made out of metal and even wood. Actually, wood is a carbon fiber.

If you have a tripod that isn't quite up to architectural work, you can still use it. I use a lightweight tripod and a piece of plywood as a computer table. This is a big help in tethering the camera to the computer.

Start with a piece of plywood or paneling about the size of the bottom of your laptop. The next thing you need is a T-nut connector, size $\frac{1}{4}$x20tpi (threads per inch). This is the size of a tripod screw. Drill a hole in the center of the plywood, just a little smaller than the center of the T-nut. Hammer the T nut into the wood. This needs to be tight, and the sharp ends of the T nut need to go into the wood. You now have a tabletop you can connect to a tripod. For added

LEFT—This is a set of tripod legs with a table attached to the top. I use this as a portable table for the laptop computer. TOP RIGHT—You can find T nuts at hardware and home improvement stores. BOTTOM RIGHT—You can see where the elastic is attached to the tabletop.

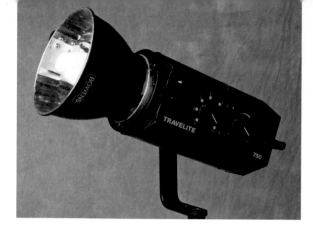

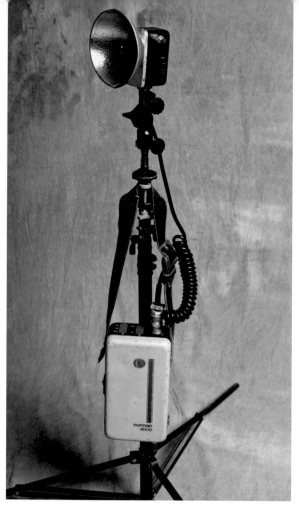

ABOVE—Monolights are probably the best lights for shooting interiors. You can connect them directly to a wall socket and they have a lot of power. RIGHT—This is a Norman 200B strobe. These strobes run off batteries contained in the pack. Powerful battery units can be extremely useful for any kind of location work.

security, you should put some elastic on the sides of the table to hold the computer.

LIGHTS

Making good light for an interior shot requires powerful lights, and generally quite a few of them. I have used strobes for most of the jobs I've done over the years, so I'm going to discuss them first. Strobes make light by running a spark through a tube filled with xenon gas. The light is instantaneous, with a duration that is generally less than $1/1000$ second. The flash built into your camera is actually a strobe, as is the flash that mounts into the hot shoe. There are much more powerful strobes that mount on stands, which are what I generally use for shooting interiors. I'm going to discuss a few of these, but first I'll point out some things about the dedicated strobes that mount onto the camera.

Strobes made to mount on the camera's hot shoe have become more efficient in the last few years, especially when you use them without any kind of light modifier. Light modifiers are things like umbrellas and softboxes. So if you just want to get light into a room (e.g., if the room is the background for a shot of a bride and groom), a dedicated strobe can do the job. Both Canon and Nikon have automated systems for controlling exposure in situations like this. The biggest problem, as we'll discuss in another chapter, is that the light will be harsh with hard shadows. If you're in a small room, a dedicated strobe may be powerful enough to work with an umbrella, but not in a large room.

My favorite lights for interiors, as well as most other situations, are monolights. These strobes are powerful units that plug directly into AC power, so you can use them anywhere you have wall sockets. These lights give you control over

the amount of light you create and the quality of the light. You can also use the built-in modeling lights to help you predict where you will have reflections. Most monolights have a built-in slave that will trigger the strobe when another strobe fires. There are a number of good monolights on the market, but I have had good personal experience with AlienBees and Calumet Travelites. I generally start lighting with a 750 watt-second light and then use smaller lights for the rest of the shot.

Often, the secondary lights I use are battery-powered. While they don't have as much power as the monolights, you don't need to look for a wall socket. There are battery packs that will give the same freedom to a monolight, so you can gain the flexibility from those lights also. I have a lot of battery-powered strobes, specifically the Norman 200B units. While these aren't made anymore, Norman does make a 200C and a 400B unit. These are 200 and 400 watt-seconds respectively. There are also very fine battery-powered units from Lume-dyne and Quantum. If you are going to do a lot of work in places where there is no power, you should look at this sort of light.

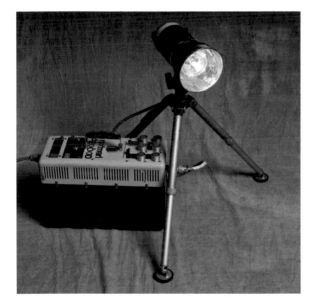

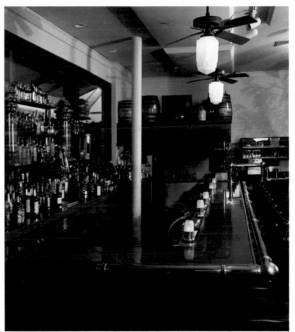

Top left—This is a Norman LH2400 head and a 2000 watt-second pack. While this gear is a little heavier than monolights, it can still be useful if you need a lot of power (e.g., if you are lighting a building from the outdoors at night). Top right—I shot this bar with quartz lights so I could integrate a little more of the existing room light. Bottom right—This is a Smith-Victor quartz light. I have some of these that I have used for decades. They can extend your reach because you can use long exposures with them. A 30-second shot with a quartz light can give you a lot of light.

There is one other sort of strobe I should mention: studio strobes. Power packs must be plugged into the wall and then the strobe head, or several strobe heads, plug into the pack. That many cables can be hard to hide on location. Still, there are two good things about these units: First, used studio strobes are inexpensive. Second, you can get very powerful units. So if you are using strobes for exterior shots at night, which takes a lot of power, these units may be a good way to go. When I used large film cameras, I used these sorts of lights. It was the only way to get enough power.

There are a few times when quartz lights might be a good way to go. They are useful when the dominant light source in a room is tungsten (e.g., lightbulbs or halogen). If the room is extremely large, then you might have trouble getting enough light from strobes, but with quartz lights you can keep the shutter open longer to let in more light. However, most of the time I can use a strobe and filter it with a full CTO (Rosco 3407) gel to be a close match to tungsten lights, and get the power I need. Quartz lights might also be good if you are working at night, shooting both interior and exterior images. You can use the quartz light outside and the strobe inside. This means that the shutter can control the quartz lights, while you can use the aperture to control both the strobe and quartz. This can reduce the amount of going in and out that would be needed if both the exterior and interior were lit with strobes.

While I have used various kinds of fluorescent lights designed for photography, I haven't used anything I would recommend. Fluorescent lights don't have a continuous spectrum—that is, they don't make all the colors in a rainbow.

Most things will turn out the right color, but a few things, particularly fabrics, won't. Also, unless you use very large banks of tubes, you won't have enough light to give you control over other light sources. There are also HMI lights, but these are so expensive that I only see them on big-budget movie shoots. They are also heavy, so as still photographers, we are very lucky to be able to work with strobes.

LIGHT MODIFIERS

When photographing interiors, we typically want to make our light sources larger. When working with a larger light source, you light a subject from more angles, which is really important. You also spread the light, hopefully evenly, over a larger area. When you can light a subject from more angles, you reduce the size of the shadows and soften the transition from light to shadow.

The easiest tool for making a light source larger is an umbrella. I consider umbrellas to be the best tools for lighting interiors. While a softbox might provide a little more control, an umbrella spreads light and gives you a larger source easily and cheaply. The spread of the light, ease of setup, and price are really good reasons for getting umbrellas. I have several sizes and types of umbrellas.

Most of my umbrellas share certain characteristics. They have a white satin interior and a removable black back. This means that I can set them up as a bounce light source or a shoot-through source. I prefer to use umbrellas as bounce lights because there is less light spilled around the room, but there are times that using a shoot-through umbrella is advantageous. I often use umbrellas that are 60 inches in diameter (5 feet across). These produce very soft light.

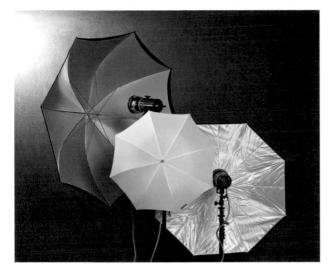

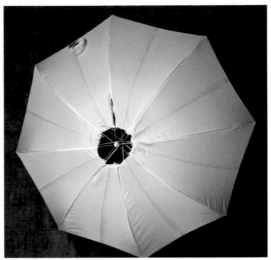

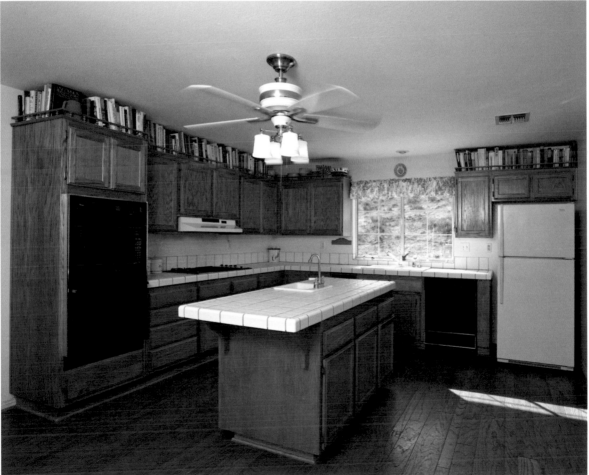

TOP LEFT—I use a lot of umbrellas in different sizes and with different fabrics. Umbrellas are easy to take on location and easy to set up. However, they can be difficult to manage in a high wind. TOP RIGHT—I made a hole in the center of this umbrella. It enables me to bounce light off the ceiling and diffuse light from the side of the umbrella. It is a very useful tool. BOTTOM—This shot was made with just the modified umbrella and ambient light. The umbrella did a good job of reducing shadows and spreading light.

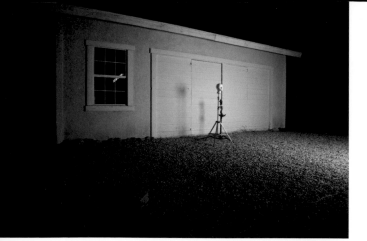

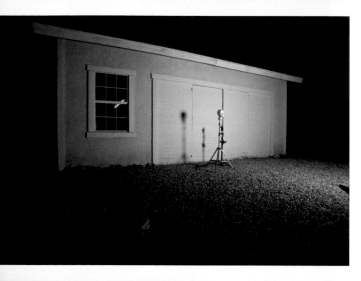

I recently got an 86-inch parabolic umbrella that creates a surprisingly tight beam of light. I also have several 45-inch umbrellas that fit when a

Top—I shot this with the 60-inch umbrella. The light is even, and the shadows from the meter and the wig head are very soft. Center—This shot was made with the shoot-through umbrella. The light is still even, but the shadows are more defined. Bottom—This is the 84-inch parabolic umbrella. Although the umbrella is much bigger, the coverage is very tight. The shadows are softer than those made using the shoot-through umbrella, but not as soft as the 60-inch umbrella.

60-inch won't. I even have a couple of 30-inch umbrellas for tight spaces. I frequently use these as shoot-through umbrellas. A shoot-through umbrella often fits better in a tight space simply because the umbrella is in front of the strobe instead of behind it.

I have a couple of silver umbrellas that are a little more efficient, meaning that more of the light you put into the umbrella comes out. The problem is that the light isn't quite as soft. In addition, I have one gold umbrella, which will make light much warmer. I don't use this much; generally, I would rather use one of the Rosco CTO filters. I also have a 45-inch shoot-through umbrella with a hole in the center. This works like a lamp shade. You point the light at the ceiling and soft light comes out the sides and out the top. The light that goes through the center bounces off the ceiling. This can give you a fast single light that works in a lot of situations. This is a 360 degree light, so you get bounce fill from all over the room. You don't have a lot of control, but the quick setup can be nice.

Parabolic umbrellas have recently come on the market. They throw a spot of light onto the subject, with some fill light beyond the spot. This can be a wonderful tool if you want to project light down a long room, but it is less useful for spreading light over the room. Keep in mind that, with these parabolic umbrellas, the exact position of

your strobe can change the performance of the umbrella quite a bit. It is also interesting to note that though the light has the coverage of a spot (it is pretty tight), the actual quality of the light is pretty soft. It's an interesting and useful combination! You can see how different a parabolic umbrella is in the example on the facing page.

Another simple modifier is the shoe cover. This works the same way that many devices designed for on-camera strobe do. It spreads light everywhere. This is a bare bulb effect, but it does make the light source marginally larger and, therefore, marginally softer. I like using this for quick work with an on-camera strobe. You can get about a dozen of these things for just a few dollars at home improvement stores.

In order to understand how different modifiers work, it is helpful to see them in the same situations. So, in the group of images shown on the following page, I set up a strobe and an umbrella in a room and took each shot from the same location. The light was above and to the left of the camera position, except for the modified umbrella. For the modified umbrella, the light was lower, so that the light from the bottom of the umbrella didn't change the foreground. The most important thing to watch in these shots is the way the shadows behave. The shadows are much less defined with the larger umbrellas. I started with the hardest light—just the metal reflector.

You can also use a strobe as a bare bulb. Sometimes that is the only thing that will fit into a space. This will allow you to light in all directions.

There are also modifiers that can be used to control the spread of a light so you can pick out detail or open up a shadow. The simplest of these tools is the bowl-shaped reflector. There are times, generally in large spaces, like warehouses, where just the regular bowl-shaped reflector for your light will save the day. Keep in mind that while this gives you a lot of light, it is very hard light with strong shadows. You wouldn't want to use this light in most offices or living rooms. A set of barn doors can give you useful control over the way this light will spread. You can also use snoots and grids to concentrate the light on a specific area.

A filter can also be used to modify light. You can put a filter over a light, or even over a window, to change the light to any color. But for

BELOW—This is a shoe cover. It is used to avoid tracking construction dirt into a new house. It is a very useful lighting tool. It will make an on-camera strobe act like a bare-bulb strobe and make other strobes cover more area. It's a really a great tool for less than a buck.

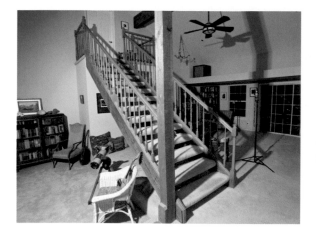

I used a 6-inch metal bowl reflector. The shadows have a lot of definition and the light is harsh. I wouldn't use this sort of light very often.

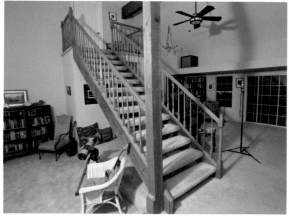

Just adding the shoe cover over the light made things much better. The shadows are still there. I would use this for a quick grab shot.

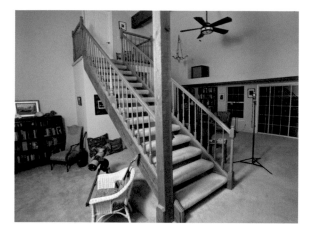

The 30-inch shoot-through umbrella is significantly softer and will fit into a small space. You do need to be careful that the color is accurate.

A 45-inch ribless umbrella. The light is similar to that produced with a shoot-through umbrella, but maybe a little softer.

The 60-inch umbrella makes the light softer than the smaller light sources. The shadows from the post and the fan are practically gone.

The modified umbrella also did a great job with the shadows. You can see how changing the position of the umbrella changed the position of the fan shadow.

Top—This strobe has barn doors that give the photographer control over the way light spreads. Center—Filters are sheets of colored plastic that fit over your lights. Be sure to get filters that won't burn. Bottom—I used a blue (CTB) filter over the lights. When I made the color from the lights neutral in Photoshop, the background, which had been too cold, was warmed up as well. This approach makes it simple to adjust the ambient light.

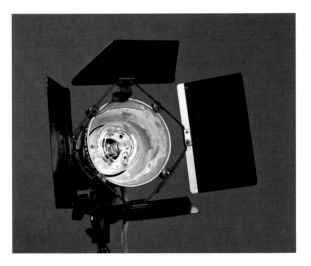

most interior work, you will be using filters to try to match the color balance of different sources of light. As I mentioned, a Rosco Full CTO (3407) will enable you to make a strobe into a close match for a tungsten light. These filters come in $\frac{3}{4}$, $\frac{1}{2}$, $\frac{1}{4}$, and $\frac{1}{8}$th strengths so that you can make lights warmer by different values. Personally, I really like warm light, so I often use these filters for aesthetic reasons, as well as balancing lights with tungsten sources.

There is also a similar series of blue filters called CTB. The full blue is the Rosco 3202 and will change the color of a tungsten light to daylight. The problem is that these filters are pretty dark and, as such, they remove much of the light from a tungsten source. There is another way to use these filters, which works well if the ambient light is too blue. If you use a $\frac{1}{2}$ CTB over your strobes, then you can remove the blue from the shot in postproduction. This will bring your strobes back to a normal balance, but you will also be removing blue from the ambient light, so that light will be warmer. This is much easier than putting filter material over a whole window.

There is also a Plusgreen series, which is supposed to work with standard fluorescent tubes. The full Plusgreen is Rosco 3304. Frankly, I wish this series worked better. I find the $\frac{1}{2}$ green sort of useful. As with all filters, it doesn't take much room or weigh a lot, so I bring it along. I also

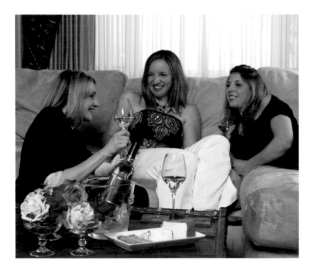

Top—I have a lot of light stands. Taking them on location can be a problem. I am still looking for a lighter but sturdy stand. Bottom—I've attached studs to my cases that allow me to mount my lights. This means I don't have to carry short light stands.

have some neutral density and a couple of colored filters in with my lights. You never know when you might need them.

LIGHT STANDS

The heaviest thing in your kit will probably be light stands. I take a huge pile of these things every time I go on location. While they don't weigh a lot and are pretty inexpensive individually, the price and the weight really add up. Since a big part of your investment is in lights, you want to make sure your stands will make your lights work well and keep them from falling over.

I look for stands that extend to at least 10 feet and have a really broad base. If I can carry five or more stands without grunting, that is a good thing. Whenever possible, I have my assistant carry the stands and the tripod while I take a separate case that has the umbrellas. They are in separate cases so the stands don't break the softer umbrellas.

One thing I do to reduce the number of stands is attach studs that the light stands mount to on my cases. This way I can use the case as a small stand. The studs can be purchased at places that sell lighting gear.

SOFTWARE

When shooting interiors, you are looking for a good balance between the brightness, color, and quality of all the light sources in a shot. It doesn't matter if the source is part of the space we're shooting or a strobe we brought to the shot, the time to get the balance right is when we shoot.

It is probably impossible to effectively evaluate a shot on the LCD on the back of the camera. A better way to evaluate the lighting is to tether the

camera to a laptop computer. This will give you a larger image and more information.

Canon cameras are bundled with software that can be useful for analyzing the lighting. Nikon includes similar software with a few of their cameras, but it can also be purchased separately. Software solutions are also available from secondary software developers.

If your camera does not offer tethering, consider connecting the camera's video output to a small TV or monitor. This will provide significantly lower resolution, and the images will be less color accurate than they would be on a tethered setup, but it is far better than trying to see a complex lighting setup on your camera's LCD.

The other tool we'll need is Adobe Photoshop. This image-editing program will enable you to take care of lens aberrations. It will let you have final control of exposure, crop your images, and more. It is not necessary to have the latest version. Photoshop 7 or later will cover the problems with shooting interiors. I will provide strategies for using Photoshop to fix specific problems later in the book. Note that this book does not offer a comprehensive look at Photoshop, just a discussion of practical tools for interior shots.

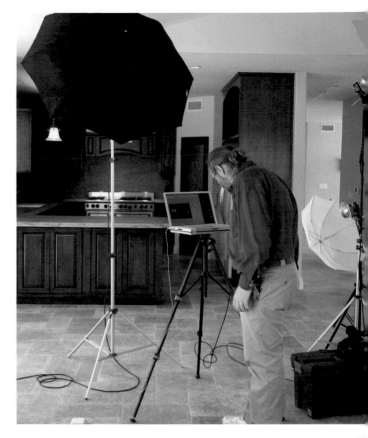

ABOVE—Here, I'm reviewing an image from the camera on the laptop. The camera is shooting directly to the computer.

3. The Shooting Angle

POSITIONING THE CAMERA

The first step in creating a successful image is identifying the best camera position for the shot. The camera needs to be positioned before the lights are set up because shadows and reflections are only important from the camera's point of view.

The important characteristics of the room and the needs of the client will come into play when determining the camera positions that work best.

Focal Length, Shooting Distance, and Spatial Relationships. Often people have the idea that using a telephoto lens can create the same effect as getting closer with the camera.

LEFT—This shot was made from a low angle. This made the image more dramatic. The rules suggest that it is the "wrong" angle, but the client is very happy with it, and so am I. In fact, I use it on some of my business cards. The lighting for this shot is discussed later in the book. RIGHT—This is the same doorway photographed from an eye-level angle. This is a nice shot and it follows the rules, but it is not as dramatic as the low-angle image.

Top—This shot was made with a 200mm lens about 6 feet from the subject. I think it creates a nice shape to the face. Bottom—I used a 50mm lens and stood closer to the subject. The shot is still good, but the face is a little more exaggerated.

This isn't so. Think about it: when you are 10 feet from a person's nose, you are also about 10 feet and 6 inches from the person's ear—almost the same distance. If you are 3 feet from the subject's nose, you'll be about 3 feet and 6 inches from the ear. Here, the difference is significant.

So getting closer to a subject expands the sense of distance between the elements of the subject. The old rule of thumb is that a wide angle lens expands perspective and a telephoto lens flattens perspective. While this is true, it is true because of the position you use with such lenses. When you work with an interior shot, you'll be using wide angle lenses, first for practical reasons, and second because it will usually make a client happy. Clients often prefer a look that will make the space seem large, and that's what wide angle lenses do: they expand the relationships between the elements in a room (e.g., furniture and other objects) so that the space appears larger.

The key in determining the best camera placment is to look for the position where the relationships between the elements of the shot are most effective. If you walk around a room looking at how the things in the room are positioned, you will often find one or two angles that are significantly better. These angles might be positions where elements don't block each other or where the space looks larger. The next step is to identify the height that works best. Usually, but not always, low angles are a problem. Often, you only see the furniture in front. An angle from eye level or above can often give a good balance.

When you pick a tripod, it is often useful to get one that goes significantly higher than your

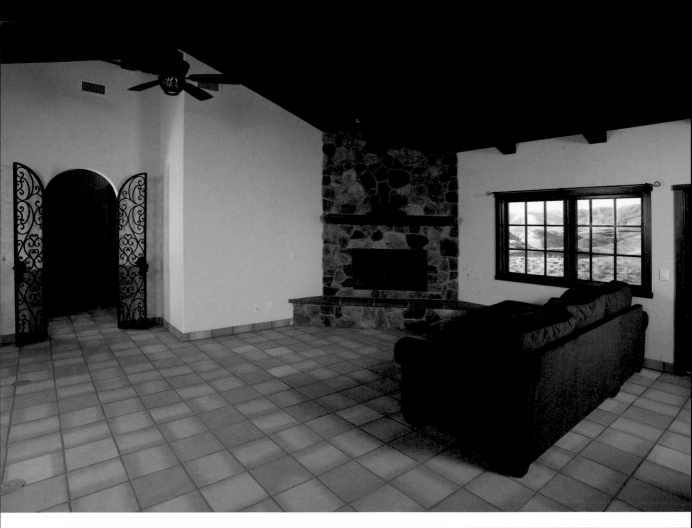

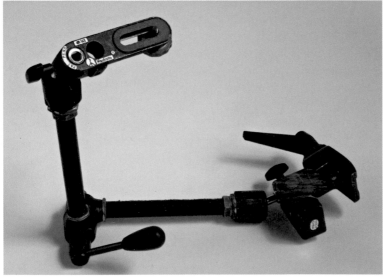

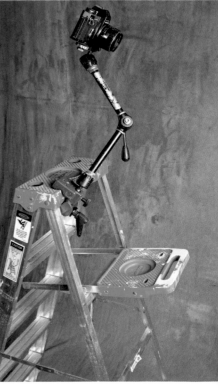

TOP—This is a very wide shot. I have always been surprised at how well the purple sofa fits into the room. You can see that the sofa is a little expanded in this view. BOTTOM LEFT—This shot shows the Manfrotto Magic Arm and a Super Clamp connected. There is a camera mount on the end of the Magic Arm. This can be connected to all sorts of things as a support for a camera or a light. BOTTOM RIGHT—The Magic Arm/Super Clamp on a ladder.

head. One way that I approach this is to use a Bogen Super Clamp and a Magic Arm. This combination allows me to attach the camera to a ladder that will put me and the camera considerably higher. The Magic Arm will move in any direction and will lock down with a single lever.

If the tripod goes to 10 feet, and I don't, then I need a way to get up to the camera. A ladder is a bulky item to take with you on a shoot, but for some spaces it can be important. One other way to achieve a little extra height is to get camera luggage you can stand on. More than half of my cameras and lights are in cases I can stand on. This makes it easier to work with a very tall tripod.

I also have a very small tripod that will allow me to mount my camera at about ankle level. I keep a lighting stud adapter, which goes from tripod size to the size a strobe uses. This way, I can use the same legs to mount either a light or a camera at a very low level.

PREVENTING AND ELIMINATING KEYSTONING

Anytime your camera sensor is not parallel to the subject (e.g., if your camera is pointed upward or downward), the image will have keystoning (i.e., parallel lines in the image will approach each other). With buildings, where you expect straight lines, you really see this effect. I don't think of this as a good thing or a bad thing, it is simply the way that lenses record a subject. In some cases it may improve an image, but in most cases, especially with interior shots, you will have to counteract the effect.

In the days when I shot film, there was no way to eliminate keystoning after the shot was made. Corrections were made at the time of the shot. This was best done with a view camera, which

Top—I try to get camera luggage I can stand on. It is easier than carrying a stepladder. The luggage isn't pretty, so it doesn't attract thieves. Bottom—These light studs have the same internal threads as a tripod. I can use them to make any camera support into a support for a light.

afforded special controls. The lens projected an image that was larger than the actual film. So if you were using 4x5-inch film, you would use a lens that could make a 5x7-inch picture. Also, the camera had a film back that could be moved relative to the lens. This allowed you to choose which part of the image you wanted to have on the film. You could literally shift or crop the image on the camera back. You could use a large

FACING PAGE—The Platt Building in Reseda. I think the keystoning in this shot makes the image more effective. The high contrast creates impact as well. ABOVE—A Toyo view camera. This camera is fitted with a bag bellows for use with a wide angle lens.

format camera to take a picture with the film parallel to the subject, but cropped so that you had less foreground or ceiling than you would otherwise have had. The view camera did other things, but this was the primary reason I used it for interiors.

Specially designed lenses, called perspective control lenses, were available for film cameras (and are now available for dSLRs), but they don't solve the problem as well as other approaches. Also, they generally provide only about an 85 degree angle of view—they're not as wide as other lenses.

Another way to solve the keystoning problem was to avoid it in the first place. You could simply shoot with the camera parallel to the subject, and in the right place for the relationships of the elements in the shot, then take the picture with everything you need in the shot. This approach would likely result in including more foreground, ceiling, or side area than you wanted in the image, but this could be cropped out later.

With digital images, we can use Photoshop's Crop tool to counteract keystoning. After you choose an area to crop (it doesn't have to be your final choice), click on the Perspective box in the Options Bar. This will allow you to change your crop box from a regular rectangle to something completely irregular. If you take the crop line and place it parallel to a line that should be straight, that line will be straightened after you apply the cropping. That is the idea anyway. It helps if the line you choose is near the edge of the frame. Unfortunately, there are times when using the Crop tool produces unanticipated results (for instance, very tall images). In cases like this, it is usually helpful to undo the crop and then re-crop in smaller increments.

You can also fix keystoning using the Distort filter (Filters>Distort>Lens Correction) or the Transform tool (Edit>Transform) in Photoshop. This topic is covered in chapter 5.

Keystoning refers to lines that converge toward the top of the frame. This happens when you point the camera upward to capture more of the top of a building. However, the parallel lines in a shot will also converge if you point the camera toward the side or toward the ground. As with keystoning, this isn't always a bad thing, and you can correct it using Photoshop. However, it is good to be aware of this issue when you

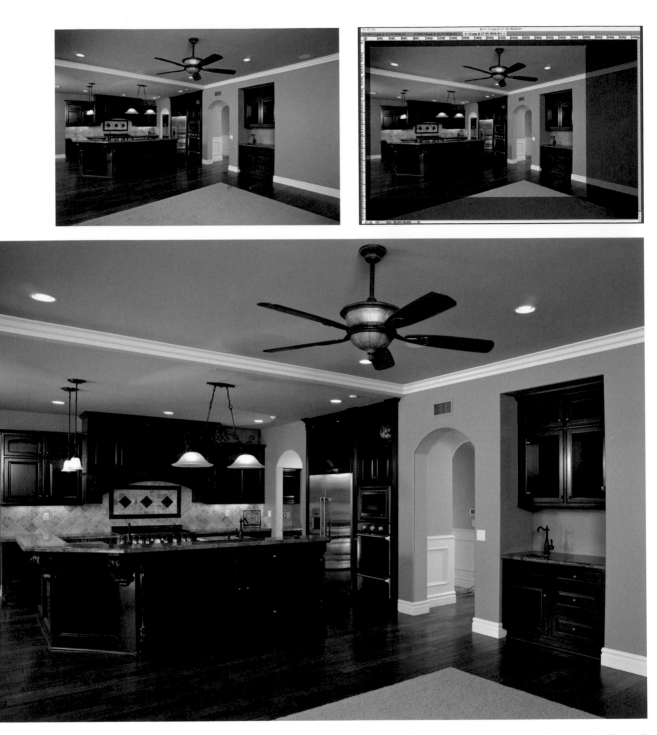

Top left—All the verticals are straight in this image, but it needs to be cropped. Top right—This is the way the screen looks when you use the Crop tool. Photoshop's Crop tool is very simple to use. You simply drag your cursor across the image to create a cropping marquee that defines the image area you want to keep. You can even set the tool to produce an image with specified dimensions and a given resolution. Bottom—This shows the image after cropping. It is more effective.

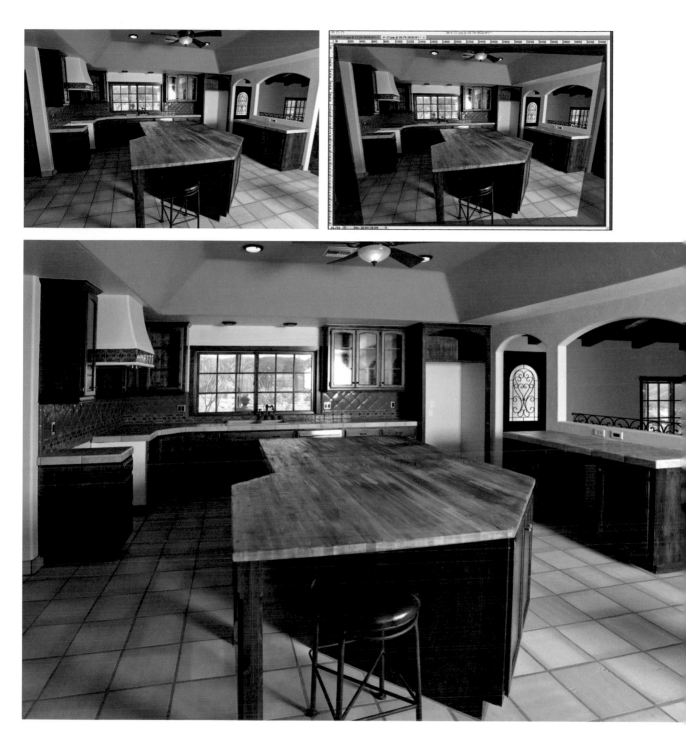

Top left—This image has significant keystoning. Oddly, the lines are coming together at the bottom of the shot. More often, the lines come together at the top. Top right—I corrected the verticals and partially corrected the horizontals. All four crop lines were adjusted. Bottom—You can see how the tool changed the shape of the subject!

shoot so you can plan how to handle the effect in postproduction. Since there are limits to how much you can correct, because you will also be cropping, you might want to shoot a little wider when you need to control converging lines.

REVIEWING THE SHOT

Architectural photography is a very detail-oriented specialty, so I will tether the camera to a laptop computer. I take a test shot (this can be done on autoexposure, but it will be the last shot that you take on auto), then examine the shot for angle and any particular problems. Now, except in the unlikely event that the photograph you just made was perfect, it is time to develop your lighting strategy. That is the subject of the next chapter.

IN SUMMARY

When you capture an image, you must be aware of the way the shape of the room and its contents are recorded. Examine the room carefully for the most effective positions for the camera. Consider the best height for the camera. When you make a shot, be sure to capture some extra space around your subject. As you've seen, you'll probably need it in postproduction. Try to decide what you'll do with the image as you capture it.

PHOTOSHOP'S LENS CORRECTION FILTER

Photoshop's Lens Correction filter can be used to do more than eliminate keystoning. Simply go to Filters>Distort>Lens Correction, and you'll find some other fixes for eliminating common lens problems.

BARREL DISTORTION

Barrel distortion is an aberration in which the lines of an object at the edges of the frame bow outward. In the Lens Correction filter's dialog box, use the Remove Distortion slider to make the correction. A positive setting will remove barrel distortion. My problem lens usually requires a setting between 3 and 9. Any lens that produces barrel distortion will need about the same correction each time, so it can become very quick to apply this correction. (See the images on the facing page.)

Once you have applied the correction, you will notice that the sides of the image will bow inward. To fix this, you will need to crop the image after the correction. (Don't crop before you apply the filter, as the correction is applied from the center of the image. If you crop first, you'll change the center of the image.)

When the Lens Correction filter is used, a new layer is created. Therefore, if you want to save your image as a JPEG, you will need to flatten it once the correction is made.

CHROMATIC ABERRATION

Some lenses have a defect that causes image colors to fringe, so you get a kind of rainbow halo at the edge of a subject. Fortunately, the Lens Correction filter offers a Chromatic Aberration slider that can be used to fix this problem.

OTHER OPTIONS

The Vignette slider will allow you to lighten or darken the corners of an image because some lenses will not expose the whole image evenly. You can also use the Vignette tool to cause this effect for artistic reasons.

The Transform filter will allow you to alter image perspective, but I find the Crop tool does a better job. You can use the Edge pull-down menu and Scale slider, located in the Transform field, to add edge effects to your images (perhaps to fill the holes you left when you corrected for barrel distortion), but I haven't found this feature to be too useful.

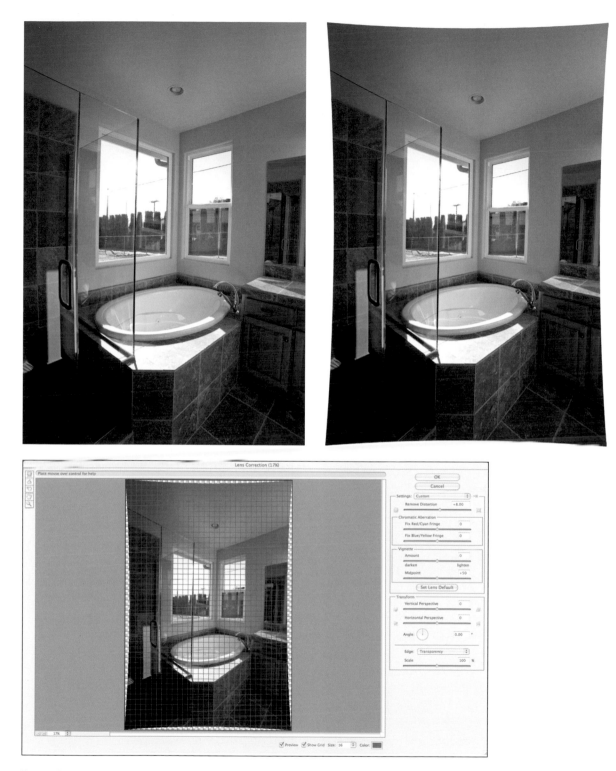

Top LEFT—The original image. Top RIGHT—The final image. Bottom—The Lens Correction filter's dialog box.

3. Lighting Interiors

SPECIAL CHALLENGES

When shooting indoors, we are presented with special challenges that we do not face outdoors. When photographing interiors, we don't have as much light. Also, indoors, there is a much greater range of light in the scene than we are faced with outdoors. When shooting outdoors, a highlight may be 128 times as bright as a shadow in which you want detail. Indoors, especially in a scene with a window, the highlight may be 1024 times brighter than a detailed shadow. Shooting indoors, therefore, we will need much more control over the way we record light.

ANALYZING THE EXISTING LIGHTING

When you encounter an interior you want to light, begin by examining the room for existing light sources—everything from lamps to windows. This will also give you a feel for how the room's lighting design was originally planned.

The thing you want to do is classify the existing lights as friend or foe. A window that throws diffused light into a room is a friend. Tungsten lights can be friends, or at least brought onto your team. Fluorescent lamps, mercury vapor lamps, sodium vapor, and so on, are generally foes because of their unusual color effects, but they can be used under some circumstances, especially with digital capture.

IDENTIFYING THE
DOMINANT COLOR SPECTRUM

When I first examine a room, I am more interested in identifying the best color spectrum for the shot than the details of how I will set the

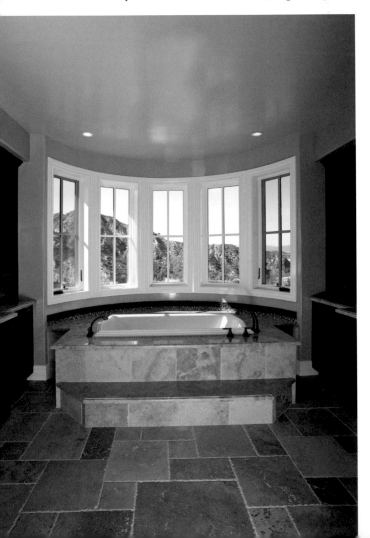

LEFT—The light from the windows was much brighter than the interior. I used three strobes to balance the interior light with the exterior light.

Above—The overhead skylights were a little help, but the mercury vapor lamps had to be turned off. Twelve strobes were used.

WORKING AROUND FULL SUN

I generally use strobes when lighting interiors. They are bright enough to overpower daylight. However, full sun streaming into the room can still create problems. With a compass, I can predict the position of the sun and pick a time of day that will work well. The sun will be moving west; I just need to know which way west is. If you are shooting several shots at a location, you can arrange the order in which the images are captured to avoid problems with daylight.

lights. Color spectrum is somewhat similar to the key of a piece of music; it tells you what will fit easily and what will be dissonant. You have three choices: daylight, tungsten, or fluorescent. Fluorescent is the most difficult spectrum to work in because fluorescent tubes, even in the same room, can have wildly different colors.

If there is a lot of daylight in the room, then you should certainly light with your strobes. If your light is mostly from tungsten sources, you would want to work with CTO filters to convert your strobes to a tungsten balance. One of the advantages to filtering strobes is that these lights will definitely not be included in your picture, so the filters are hidden also. If you put filters on room lights, the filters may show in your shots.

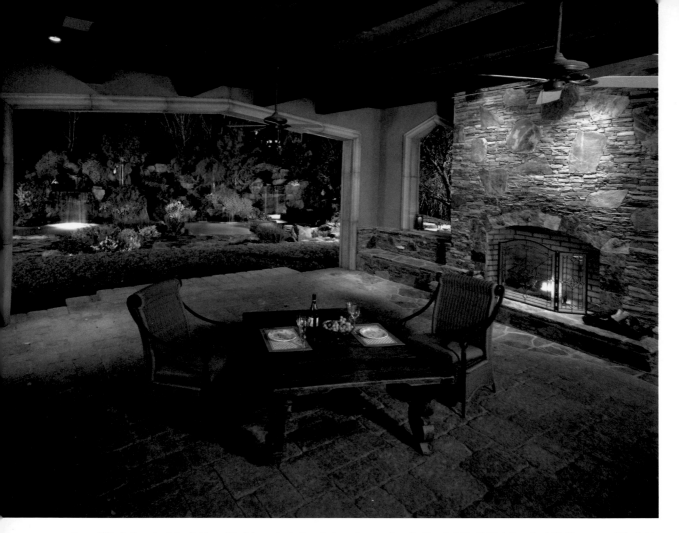

Above—This shot required nine lights and took hours to do. I used a tungsten spectrum for the shot. The lights I placed outside the room and the lights on the waterfall were all tungsten balance. I used strobes inside the room with full orange filters. Positioning all the lights was time consuming.

Facing page—This shot was done with a single large monolight and a 60-inch umbrella. I used a daylight spectrum, largely because of the window light. Although the lamps in the shot were not corrected to daylight, the color seems to work. This shot had to be made very quickly, but it worked well.

THE FORECAST

I like overcast light because of the softness, so I will look at the weather before I schedule a shoot. This is especially important if you are also shooting some exterior images.

DEVELOPING THE LIGHTING STRATEGY

I use strobes for most interiors. If I don't know anything about a location, I will bring strobes. They are the most adaptable lights for interior photography. I will take quite a few of them with me on a job—say, seven or eight. The easiest tool for manipulating the light from the strobes is a big umbrella, at least 45 inches, but 60 inches or larger is often better. If everything is average, and often it isn't, I want a big umbrella, placed near

the camera. I may need additional lights on the sides, and I may have to hide lights somewhere in the shot.

Generally, there are only a few places you can possibly put a light. Lights outside of the frame are easy to make look natural. For instance, a light from either side can always look like window light. A light that is visible inside the frame will need to be much more subtle. You can put a light on the other side of a kitchen island to bring up the tonal values on a stove, but if you

Top—There is a light hidden behind the wall at camera left and another in the doorway at the back of the shot. Bottom—In this shot, there are lights hidden behind the wall on the right and behind the sofa. These small lights add definition to the image.

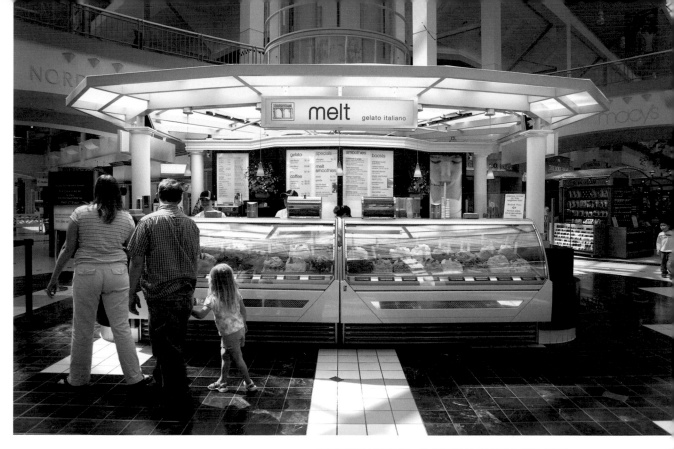

Top—This image was made for a chain of gelato stores. I like the way the people relate to the product. Bottom—Here, I am examining the light balance and color on a laptop tothcrcd to the camera.

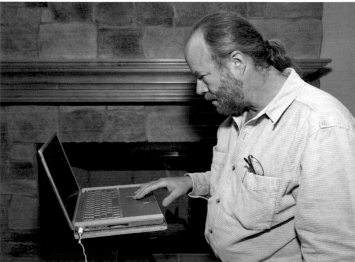

add a lot of light in a place like that, it can look really weird. One important source to consider is bounced light off the ceiling. This can look very natural, but you want to keep the bright ceiling out of the frame. If the ceiling isn't white, your color can be ruined.

Positioning the First Light. In most cases, I will set up my first light as near to the camera as practical and as high as possible. I use a powerful monolight for this. My first choice for a light modifier is a 60-inch umbrella. An even larger umbrella might be a good tool. The purpose of this light is to open up any shadows from the existing light sources. This will bring down the contrast, which is an important goal in lighting

most interiors. Also, a large light source creates spill light, which will fill in all of the shadow areas. Since the light is above the camera, shadows will fall behind objects and, hopefully, reflections will not go toward the lens.

DAYLIGHT, TUNGSTEN, AND FLUORESCENT LIGHT

Basically there are three kinds of light that a camera can work well with. The first is daylight, and this is the easiest. Strobes and daylight have the same color balance, so they work well together. The second is called tungsten light. This is the light that is emitted by standard lightbulbs. You can get continuous lights that work with a tungsten balance. Lights for movie and video usually have this color balance. You can also convert strobes to this balance with a CTO filter. If your shot is lit with bulbs and there is not a lot of daylight, this will be a good color balance to use. Finally, a lot of spaces are lit with fluorescent tubes. The camera can do a good job of balancing this color if the tubes are the same type and age. You can get green filters to balance strobes closer to fluorescent tubes, but it does not work well. Other types of lights, like mercury and sodium, are even more difficult to balance than fluorescent tubes.

Balancing Mixed Lighting. Next, you will need to ensure that all of the lights in the scene are producing light in same spectrum as the dominant light source. If you are shooting daylight spectrum with strobes, you don't need to do anything. If you are shooting in tungsten, you will want to put a Rosco 3407 CTO or equivalent filter over your strobe. This will make the light about 3000K degrees, which is a movie light spectrum. You may need additional filtration, but you won't know until you shoot a test exposure. If I am trying to balance to fluorescent tubes, I will probably use the Rosco 3315, which is the ½ Plusgreen. It has worked better for me than the Fullgreen.

You can change the color of the light sources in your shot, but this is not always necessary or helpful. If you control the exposure so that the light source in the shot is a bright value but doesn't add much light to the surroundings, you may not need to adjust color. Often this is the case with standard lightbulbs. Whites and blacks are self-cleaning—that is, a white or a black doesn't have a color cast. So, a bright white bulb is white, regardless of the color balance. If the lamp is bright but the light doesn't fall on any-thing, you may be okay. If the lamps are critical, you can replace a tungsten bulb with a photo-flood BCA bulb. This runs at almost 5000K degrees, similar to daylight. However, doing this is dangerous. The bulb runs *much* hotter than a normal bulb, so only turn it on when you are actually doing an exposure. You can also use a Britek or similar strobe with an Edison base, but these do not spread light like a bulb, so they often don't look natural. Also, you can put a Rosco 3202 CTB Full blue over a lightbulb. Unfortunately, this will reduce the output of the bulb substantially. You can use a Rosco 3308 Minus-green filter over a fluorescent light source, but because fluorescent tubes are so variable, this doesn't always work. And, in any building, the tubes may have been replaced at different times with different color tubes, so fluorescent lights can be very difficult or impossible to control.

If you want to change a window to tungsten balance, you can do this too. The Rosco filters are available in rolls, so you can attach the filter to the outside of the window. I would suggest the ½ CTO 3408, which is the half orange rather than the full orange, as the additional blue will make the color from the windows feel a little

ABOVE—Although I didn't correct the color from the existing light in this shot, the color works well. If the lights don't illuminate much of the subject, you can usually work with them. The lights under the cabinet were, potentially, a bigger problem than the lights hanging in the middle of the shot.

more natural. The filter material can be reused, which is good because it is expensive.

Fixing Color Imbalances in Photoshop. You can certainly do much of this color control after the shot in Photoshop. There are good reasons for doing so, including the fact that you don't need to buy filters or bring them with you. If you shoot in RAW (and you should always shoot in RAW), you can convert the shot to several color balances and then use Layers to make a final shot with adjusted color. We'll discuss this at length in the next chapter. That said, there are occasions when you should fix the color while you shoot—for instance, if there is a client watching and you

would prefer not to tell him/her "Oh, the color? I'll fix that later in Photoshop." Another consideration is, if you are shooting a large number of images that will require a similar fix, it may be better to avoid having to do a lot of fixing after the shoot. I think it is always advantageous to reduce postproduction work so you can deliver images to your client sooner.

A Test Shot. At this point, it is time to take a test shot. Carefully review the image to ensure that the color balance, exposure, and contrast are where they need to be. Also make sure there are no problems with the strobe placement, reflections, or shadows.

You may find, at this point, that you need to adjust the exposure. Fortunately, when working with strobes, adjusting the shutter speed will affect the ambient light but not the light from the strobes. The strobes are only on for about $\frac{1}{1000}$ second, so they add the same amount of light to a shot regardless of the way the shutter is set. This is really useful because you can effectively change the continuous light sources in your shot without changing the light from the strobes. If you find that the ambient light is too bright, then you can use a shorter shutter speed. If it is too dark, you can use a longer speed, without affecting the light from the strobes. (The only caution here is that the shutter must be completely open when the strobes are triggered. This means that you will have to set the shutter to the sync speed of the camera or any longer shutter speed.)

If you find that the contrast is too great, try increasing the power of the strobe. If the windows were too dark, then you would need to use a longer shutter speed. If a single lamp was too bright, you might want to put metal window screen over the bulb to reduce the light from that lamp, or put a smaller bulb in the lamp. (Metal window screen is really helpful at reducing the light from a bulb or a strobe.)

BELOW—In this shot, I used rolls of half orange filters outside the windows. The existing light was very warm. My lights were balanced to tungsten. If the windows had been bluer, the shot would not have worked well. I don't usually have to correct a window! The filter also made the windows less bright, which was an advantage.

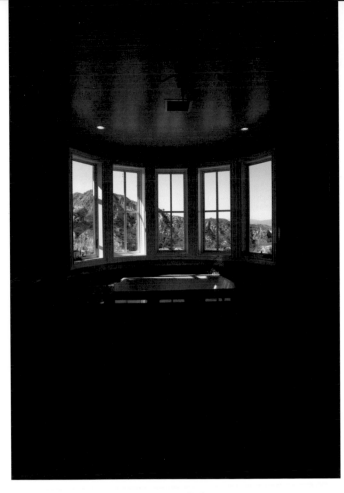

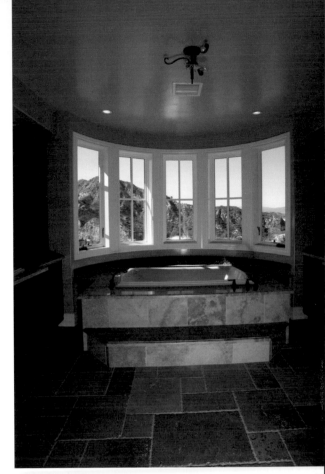

Top left—This is the first shot of this image. It shows the way the camera saw the light. I used this image to repair the reflections in the windows—more on this later. Top right—This shot was made with a single strobe. There is much more light inside the room! Bottom—Here, two strobes were used to light the room. There are some reflections in the windows, but they are not too bad. There are a few perspective issues. The shot is good but not perfect.

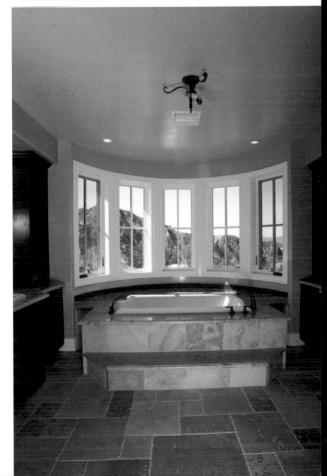

Additional Lighting. For many small rooms, one light will work. For other jobs, it might be good enough. But, of course, we would really like something better than "good enough." So let's look at some tools we can use to finesse the shot.

Battery-Powered Strobes. Since I use a wide angle lens and a dSLR for architectural shooting, an aperture of f/8 or f/11 usually provides enough

depth of field. Therefore, I can use lower-powered lights as additional light sources in most situations. I often use 200 watt-second battery-powered lights in secondary positions. The DC power makes it much easier for me to place the lights, as I don't need a power outlet. The small size of the strobe head, compared to an AC-powered monolight, also makes it easier to position these lights. There are several sorts of battery-powered strobes available from Norman, Lumedyne, Quantum, and other manufacturers. While larger and more powerful lights would work as well, the chief goal is to have a large number of strobes. I usually take out seven battery-powered lights in addition to the monolight. The idea is that control over light placement is more important than power.

Top—A Norman 200B strobe with an umbrella (this shot doesn't show the battery pack). These strobes are helpful because they are small and do not need to be plugged in. Bottom—Here I am with a monolight with a large umbrella, with a Norman 200B off to the side.

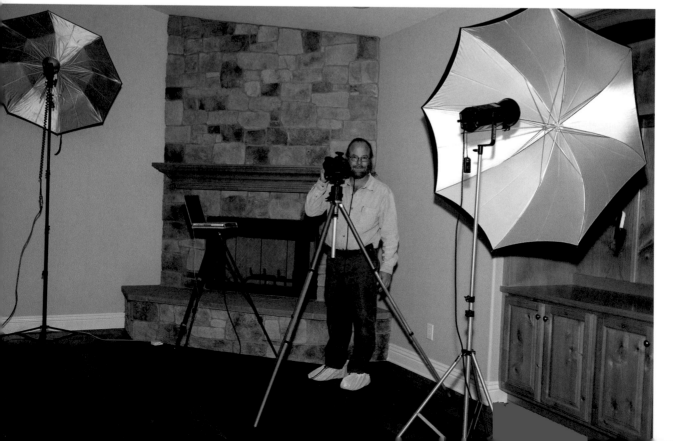

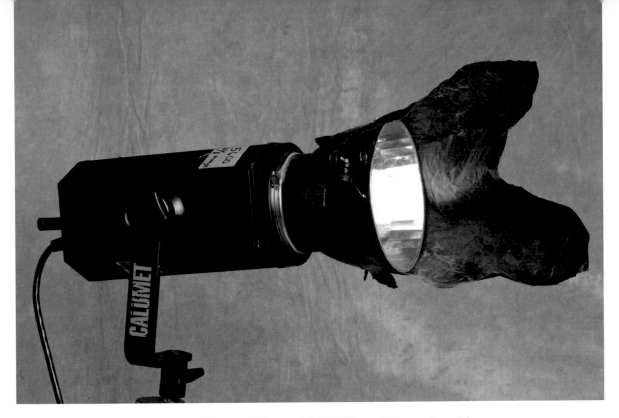

ABOVE—You can use Cinefoil, a black aluminum foil, to control the spread of a light. It is easy to shape and it won't burn.

Umbrellas. Umbrellas are the first and best modifier for interior work because they spread light evenly over a large area and create soft light at the same time. As I mentioned, I start with a large umbrella. I usually set up umbrellas as bounce tools, rather than as shoot-through light sources. This gives me a little more control over the way the light spreads.

The broad light from umbrellas is useful for opening up large parts of the shot that are too dark. Your light has a more pronounced effect on shadows in a mixed-light situation than on the highlights. Often, I need one or more strobes with umbrellas at the far sides of a shot in order to ensure the light feels even. Since light is reduced the farther you are from a light source, it makes sense to add lights to the sides of a wide shot.

When I am pressed for space, I will use a shoot-through umbrella. This is especially good in a bathroom because the light that bounces back off the umbrella will bounce again into the shot and will soften the overall light. This extra bounce means that you will have less control over the lighting when you are working with a shoot-through umbrella. I sometimes use silver umbrellas when I want the light to be a little harder or when I need a more efficient reflector to get enough light.

Bowl Reflectors and Cinefoil. I may use a strobe with just the standard metal bowl reflector. This lets me put more light in a specific area of the shot. In addition, a light with just a metal reflector will add contrast and hard shadows to the area illuminated. This can help identify some part of the shot as a focal point for the image.

Lighting Interiors 51

A HELPFUL STRATEGY

I started lighting interiors by placing a light in the shot, taking a Polaroid test image, then adding more light or modifying the light (by "modifying," I mean moving the light, adding an umbrella or other modifier, or changing the power of the light). This is a good way to learn and, with a digital camera, you won't need to shoot all those expensive Polaroid images. Because I now have more experience, I am likely to set up several lights before I start testing and modifying.

I almost always use a barn-door attachment when I use these small light sources in an interior shot. This lets me control what part of the shot gets the light. Cinefoil, a black aluminum foil that can be wrapped around your light source to control the shape and spread of the light, is another useful tool.

Adding a small amount of hard light on top of the softer light from an umbrella can enhance the sense of three-dimensionality in an image, so I sometimes direct hard light from a similar angle to an umbrella.

Bare Bulbs. There are a couple of light sources that are ideal when working in a tight space. The first is just a bare strobe tube, called a bare bulb. This is not usually my first choice, but it fits into a small space and illuminates 360 degrees, which can be incredibly helpful. I sometimes modify a bare bulb with a shoe cover. (These slip over street shoes so you can avoid tracking dirt into an interior. They are available at home improvement stores and are low-cost, lightweight modifiers. Just be sure to get the white ones.) It makes

the light source a little bigger, softening it just a bit. It spills the light everywhere and reduces the output, which makes it useful for a light hidden inside a shot. I'll use a light with the shoe cover behind short walls. It gives good light out the side and makes for a ceiling bounce that is easy to hide.

How Many Lights? The first thing that will help me decide how many strobes I need is the size of the room. If you're lighting 1500 square feet, you'll need more light sources than you will in a 10x10-foot bedroom. The second thing that will affect my original setup is the ambient light in the room. If the room has a good quality of

FACING PAGE—I used a little hard light on the front of this shot to create sparkle and help separate the area from the rest of the room. I also used a soft-focus filter to create a more magical effect. Four strobes were used. RIGHT—One-size-fits-all shoe covers fits on monolights. When using a shoe cover, don't forget to turn off the modeling light. The heat from the modeling light will burn a shoe cover.

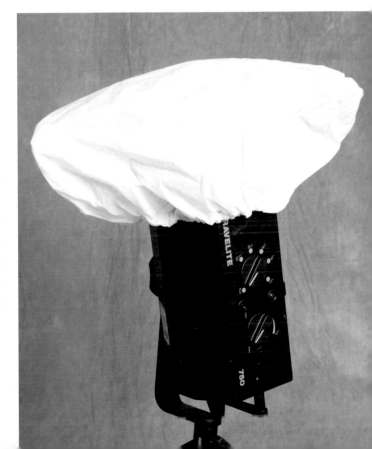

FACING PAGE—I used just the shoe cover on a camera-mounted strobe in the hall. I used a second strobe, with an umbrella, inside the room. The shoe cover on the light gave good separation to the doorway. ABOVE—I used the shoe cover on the light in the shower. You can see the light it created.

ambient light, then I might only use a strobe to make the shadows lighter. In this case, I would usually start with just one light unit. Why create complications?

Establishing Balanced Power. The next consideration in designing the lighting for the shoot is the balance of power between the strobes. We've already discussed the balance with the ambient light and how you can affect that by adjusting the shutter speed. If a strobe is overwhelmingly brighter than the light from a second strobe, the light might not have the desired effect.

When I set up a light, whether it's the first or fifth strobe in the shot, I almost always set the strobe to half power. This way, when I see the image on the laptop screen, I know I can increase

or decrease the power. As I mentioned, I do most of my work with one monolight and quite a few smaller, battery-powered strobes. One of the reasons why I like this setup is that I can balance the scene by changing the output of the monolight, which offers continuously variable flash output. Since the monolight is generally positioned near the camera, I can balance the shot quickly by changing the setting on the power dial. If I decrease the power on the monolight, the light in the middle of the frame will be reduced. If I then change the aperture on the camera to let in more light, the sides and center of the shot will get brighter. This will also affect the ambient light, so I may need to adjust the shutter speed. As you can see, I might be able to perfect the light, making changes to just the monolight and the

you have six strobes set out over a large room with a staircase, you might find that adjusting the lights can be annoying, especially when you've already done a couple of shots. There are monolights, including some by AlienBees, that allow you to control the light output via a wireless remote. This could be quite helpful.

IN SUMMARY

So, in building the best-possible image, we concern ourselves with the balance of the color of the light source, and the balance of power of the various light sources, strobes and ambient, in the shot. We evaluate these concerns using a laptop tethered to the camera, if possible. We'll change color with filters and change the power settings and position on the strobes to balance light.

When looking at a room, it is important to pay attention to the existing light. The lighting in the room is part of its design, and it establishes how everyone sees the room. If you change the lighting radically, people may feel you haven't properly captured the room. When you consider your shooting options, you'll want to know how the room is lit and how the movement of the sun will affect the overall lighting at the time of the shoot—and your lighting strategy should be built around the qualities of the existing light you find.

Finally, the intended use of the image will influence several aspects of the shoot. Consider how the image will be used and the size at which it will be viewed. Much postproduction work, and even the amount that you will bill your client, will depend upon the final image usage. For example, creating a web image doesn't require as much work as an image for print.

ABOVE—I had very little time to do this shot, so I only used one light—a monolight with a 60-inch umbrella. Despite the time constraints, I think the image turned out well.

camera settings. Still, it rarely works perfectly, and I will often have to adjust the power of the other strobes. I don't want to sound lazy, but if

In order to do a good job at controlling color and the balance between the ambient light and your lights, you must have your camera tethered to a laptop. The software for this tool is provided by Canon on their dSLR camera, and by Nikon on some of their dSLR cameras. You can acquire software from Nikon, and from other sources, for cameras that don't come bundled with tethering software. Usually the tether is a USB cable, and you can buy a backup cable quite cheaply. There are wireless systems available, but I don't think they provide a significant advantage when shooting architecture. They might be useful when shooting portraits or fashion.

Obviously, if you are really just adding light to make a better background for a portrait, tethering is less important. Also, if your goal is a quick shot for a real estate agent, you may not want to bother with tethering, but that doesn't mean that it wouldn't be a good thing. For instance, if I was setting up a shot of a couple in a church and had the time, I would tether the camera, as doing so would allow me to find out more about the light in the church and on the couple. When I do a studio portrait, I always tether the camera while I do the setup. When the setup is finished, I'll remove the tether and shoot to the card in the camera (it is quicker to shoot to the internal card). Even when I'm shooting interiors, I may remove the cable after the first shot and shoot additional angles.

In addition to evaluating the balance of the shot, you should determine if you have enough overall light. The easiest way to do this is to look at a histogram. The histogram is a mathematical representation of the number of pixels in each light level. So if your shot is very dark, whether it is because it should be or because you need to add more light, the histogram will show most of the pixels on the left side of the graph. If your shot is very light, then most of the pixels will be represented on the right side of the graph. If the pixels run up against either side of the graph, then you have some image data that won't be recorded. If the histogram is running toward the left side and you want the shot to be lighter, you should add more light by choosing a wider aperture or selecting a higher ISO number. If the shot is too bright, reduce the size of the aperture or select a lower ISO number. (Keep in mind that changing the aperture will affect the depth of field in the shot.) For most current dSLR cameras, noise is not a problem until your ISO is over 400, and many cameras can use a much higher ISO, so the ISO is often a good setting to change.

I have not mentioned meters because they are of little use in this kind of work. If you are shooting a wedding with a dedicated strobe, then your camera meter will be very helpful. But whenever you are shooting with a monolight or other off-camera strobe, such as battery-powered lights, the camera meter is unable to evaluate the amount of light from the strobe. This means the built-in meter is useless. You can get a handheld meter that will read strobes. However, you will do better to use the tethering option to evaluate the light in the image. The information available from the laptop is much better. You can guess on the first shot and do about as well as the meter will do. Meters were incredibly useful with film because each Polaroid proof cost a couple of dollars. With free proofing, the meter is much less important. You always get more information from the proof, whether on the back of the camera, on a laptop, or even a Polaroid proof.

LEFT—This shot has a lot of tones, particularly midtones. The highlights were more critical than the shadows. RIGHT—The histogram shows the distribution of tones. This one shows that some shadow detail was lost.

5. Photographing Exteriors

WAITING FOR THE RIGHT LIGHT

When you photograph the exterior of a building, the same concerns about light apply: do you want hard or soft light? Which direction should the light come from? The problem is that you can't just move the light source from one side of the building to the other. While you can wait for the sun to move from east to west, or come back if the light needs to be from a more easterly direction, nothing is going to give you a strong light source due north. If you wanted to use a reflector to fill in the shadows, you would have to build a wall about the size of your subject. The good news is that you can have soft, even light. The bad news is that you'll only get it on an overcast day. As a consequence of this, one of the most important tools for shooting exteriors is the patience to wait for the right light.

I've included several images of the same building, shot at different times of day. The reason I wanted to use this building, the Indianapolis Public Library, is that it combines modern steel and glass construction with older limestone block construction. It is unusual to see these materials together. When the light is behind the building, there is just skylight on the limestone blocks, which is even but cool. You can see some of the light inside the stone part of the building, because the overall light level is not that high.

The light is coming through the open connecting area in very interesting ways. Also, light is reflected on the top of the steel and glass structure, which is difficult. The sky is quite bright. The foreground is disappointingly dull. The shot was made around 9:00AM.

I came back about three hours later. The top of the building is better defined. The definition in the limestone part of the building is better. You can also see how different the limestone sign is, now that it is in the sun. Unfortunately, the connection between the two buildings is not as interesting as it was in the first shot. The front of the limestone part of the building is still in shadow, so it is cooler and doesn't have strong shadows.

When I returned the next afternoon, I got a shot with some cloud cover as well as one under full sun. One of the strongest differences between these two shots is how much lighter the shadows are in the shot with cloud cover and how much more saturated the grass is in the shot with full sun. The full-sun version has much better saturation and color than the other shots. The cloud cover behind the building works well here. You can see the strong shadows particularly well in the limestone part of the building.

The last shot was made with the cloud cover. This shows the building well, but you can't

LEFT—This image was shot early in the day. The light in the center of the building is quite interesting. RIGHT—This shot was made a few hours later. The front of the older part of the building is still in shadow.

LEFT—This version of the shot was made with full sun falling on the building. The color is much stronger in this shot. RIGHT—This shot was done with clouds covering the sun. This gives you much softer light.

always get the clouds to cooperate. The light came from a large part of the sky, so it has a much softer quality.

I corrected the perspective on all of these shots, and I also adjusted the overall exposure to be a better match. I didn't lighten the shadows or darken the highlights, so that the changes in the images better represent the changes in the

light. I also left the color fixed at the same setting, so that you could see how the color varies as the sky changes.

CHANGING PERSPECTIVE

One other thing that will help get better images is to be able to change the height of the camera. When you shoot interiors, this is generally a

pretty simple affair because, inside most rooms, you can't really get very high. Even when you are shooting in a room with a high ceiling, say a hotel lobby, you can generally get to a mezzanine and shoot from there. This can be a very important time to have an assistant, so that you don't have to run up and down stairs to make small adjustments. When you are shooting outdoors, you may need a position that is only five or so feet higher than the ground, in which case you can stand on your car. The roof of my car has some permanent footprints on it. Since some of my clients are construction companies, I often have access to various kinds of lifts: scissor lifts, forklifts, and high lifts. I find that, in combination with a wide-angle lens, these can be quite effective.

There are other good options. Often you can use a nearby building or a parking structure. Parking structures are particularly nice since the sides are generally open and you don't usually need permission. Finally, there are helicopters; unfortunately, these are expensive and dangerous. It is simpler and cheaper to rent a lift. If you have a fear of heights, this is going to be difficult work to do. Even if you don't fear heights, it is best to avoid this kind of shot on a windy day.

ABOVE—This shot was made from high lift vehicle, which is a sort of a super forklift.

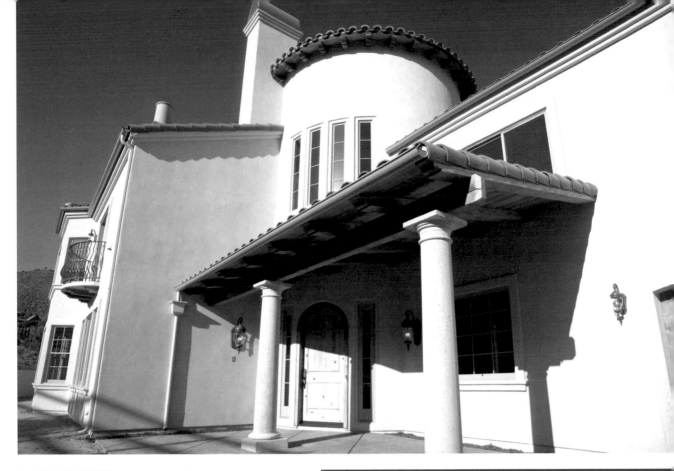

BLACK & WHITE

I rarely get a client who wants black & white shots of the interior of a building, but there is some call for black & white exterior shots. Often people want to use the exterior of a building as a sort of logo. If you simply convert a shot, generally using the mode conversion from Photoshop, the image might be disappointing. Often I will use one of the individual channels and convert that to monochrome. In this example, I used the red channel.

When I shot film, I did the same thing using a colored filter over the lens with black & white film. Of course, you had to get the shot right in the camera.

Monochrome images, black & white usually, are also useful for exteriors at night. Often, buildings are lit with mercury vapor lamps or

Top—In postproduction, I converted just the red channel of the file. I think it makes for a dramatic image. Bottom—This shot was converted to black & white using the Mode tool (Image>Mode>Grayscale) in Photoshop. I prefer the look of the top image.

even sodium vapor lights. Both of these light sources have a weird spectrum that you can't correct completely. However, if you shoot for a monochrome image, you can easily get an effective shot. I often add a little color back into a shot, generally red and yellow, to give the black & white shot a little warmth.

BELOW—There were a lot of different colors of light in this shot, including the traffic signal! By shooting for a black & white image, I made the shot much easier to do and more effective.

6. Postproduction Enhancements

Photoshop is an integral part of any professional photograph, but especially interior images. The biggest reason for this is that Photoshop gives us control over perspective. When photographers used view cameras to shoot interiors, the camera offered perspective control. With dSLRs, that control is limited or does not exist, so we have to perform this vital manipulation in Photoshop. Of course, there are many other aspects of the shot that will benefit from some Photoshop editing as well.

The problem with discussing Photoshop is that it is such a vast subject. Many books have already been written about Photoshop, and I am not able to devote the rest of this book to this one subject. Therefore, this chapter is devoted to the specific aspects of Photoshop that are particularly useful to a photographer who shoots interiors. I am going to present a simple discussion of the tools that are most useful.

There are always several ways to complete a given task in Photoshop, and the methods I discuss here are not necessarily the best. I am not as concerned with developing a rapid workflow as I am with giving you a simple way to fix images. If you are already familiar with Photoshop, please adapt these ideas to your own workflow. If you are not experienced with Photoshop, I strongly suggest that you take time to familiarize yourself with all of the things it can do for your images.

Note that there are many other programs that you can use to do much of if not all of this editing work. However, to keep this chapter manageable, I will only discuss Photoshop and the programs bundled with it: Adobe Bridge and Adobe Camera Raw.

USEFUL TOOLS

If you are not used to the Dodge and Burn tools, the selection tools, and what you can do with Curves, you might want to get a little practice with these tools. I will point out that the Dodge and Burn tools are much better in more recent versions of Photoshop. So if you use an early version of the program, you may not be able to do all the things that are discussed in this chapter.

I should also point out that my goal is to create an 8-bit image. While I know that a bit depth of 16 or 32 provides a superior image, I have never had a client who wanted this kind of file. It is a photographer's responsibility to give clients an image that meets their needs. You might have multiple layers or create a HDR file, but you will probably need to create a final image that can be saved as a JPEG or flattened 8-bit TIFF file for the client.

Layers allows us to blend multiple versions of an image, which can create better detail or color in parts of the image. HDR imaging allows us to blend multiple exposures into a single image file

with more detail in the highlights and shadows. HDR imaging is particularly useful when you can't use your lights to make an image, because it brings much more information to the shadows and highlights. However, the process can result in an image that is disappointingly flat and, as we'll see, it does not give you nearly as much control as lighting a shot.

Let's look at a single image. I hope this will give you some idea of what Photoshop can do.

A CASE STUDY

In this case, I was looking for a place with difficult lighting. I chose this spot based on the windows and the light falling on the right of the camera. I actually waited a while to bring that light more into the frame. My other consideration was the placement of the front door. I liked this location, but I might have been positioned a bit higher to separate the door from the banister. You can see what the shot looked like with the camera set to autoexposure in the image below.

To begin, I lit the shot with my strobes. As we've discussed, strobes give you control over the contrast in your shot in a couple of ways. First, you can fill in your shadows by adding more light. Second, you can control bright ambient light by adjusting your camera's shutter

Below—This is the way the camera captured the image on automatic. No lighting was added.

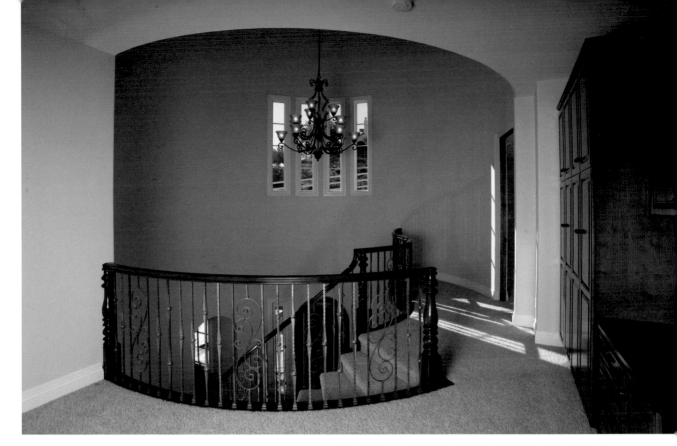

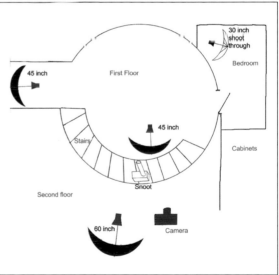

Above—The only thing I did to this image in postproduction was to convert the shot from RAW. In this scene, I didn't need a lot of power, but I did need light in a lot of places. In a shot like this, the goal is to bring the contrast down. If you look at the unlit version of the room (facing page), you can see that there is too much black, too much white, and too few tones in middle. For this second shot, I used a 60-inch umbrella with a 750 watt-second monolight near the camera to ensure the light would cover most of what the lens covers. I then added four other lights. Right—Here is the setup. Note that I used a total of five lights.

speed. Finally, the size of the light source gives you the ability to create hard or soft shadows. I used five strobes plus some daylight to light the image above.

The first strobe I positioned was a monolight behind and above the camera, on the second floor. Next, I added three more strobes. I placed them to fill in areas of the shot that would otherwise be in shadow. I needed to have light in the bottom of the cylindrical entry, opposite the front door, so I added a battery-powered strobe, placed opposite the door. I spread this light with a 45-inch ribless umbrella. I also used the same setup in the ground-floor hall to the left

ABOVE—You can see the white plastic snoot I used over the light on the stairs. This snoot is actually a piece of PVC pipe from Home Depot.

of the camera. I used one more battery-powered strobe, modified with a white shoot-through umbrella, in the bedroom on the right side of the camera on the second floor. The shoot-through umbrella spreads light behind and in front of the strobe, so I didn't need to be critical with light placement. Remember, I only needed to be able to see into this room, I did not need to see any details. You can see the placement of these lights in the diagram on the previous page.

I still wanted more light on the stairs and on the ceiling. I put another Norman battery-powered strobe on a very small light stand, actually made from a vise grip. I put a piece of white plastic plumbing pipe on this light, something I found at a Home Depot. This home-made snoot put a lot of light out the front (in this case, toward the ceiling) and put out some light from the side. I was very happy about how the light worked in this shot.

I spent a little more than two hours working on the shoot, and I still needed to clean up. I also made a series of shots in the same place for the HDR file. I made eight exposures, each separated by one stop. I did this tethered to the laptop, so I could make all my exposure changes without even touching the camera. This meant that everything was in register. I made all these images without the strobes. HDR imaging can allow you to control the contrast because you have plenty of information about the darkest and lightest parts of your image.

Basic Editing. Let's return to the image made with the strobes. The first thing I did was open all the images in Adobe Bridge and choose the version I wanted to work on. Usually, with architectural images, this is the last version you shot. After all, why would you keep shooting when you're happy with the shot? Still if you were working on a portrait with an interior as the background, this would be the starting point.

Bridge is an excellent program for editing, and since it is linked with Camera Raw and Photoshop, it is quick to use. When I opened the shot in Camera Raw, I made the shot very slightly darker and increased the Vibrance and Saturation by a small amount. I also adjusted the Color Temperature slider to make the shot about 250K degrees warmer. I like warm light. When I finished this, I named the file V1 and saved it as a JPEG. Then I made three other versions: a version 1.5 stops darker (V2), one 1.5 stops lighter (V3), and finally a lighter version that was balanced for tungsten light and 1 stop brighter (V4). You could make a duplicate layer in Photoshop and then modify the layer, but doing this in Camera Raw is better. Camera Raw works with your original RAW file, so that a brighter image

picks up more information in the shadows, detail that wouldn't be in your normal conversion. Making a duplicate layer brighter just makes the pixels you have brighter, it doesn't make any new pixels. The same is true for the underexposure; it gives you more information in the highlights. I suppose you could change the color effectively using the Tint slider, but I like working with color temperature. It is easy for me to control, and I think in terms of color temperature.

I opened up all four versions of the image in Photoshop. In the Layers palette, I changed the background to Layer 0, and then I pulled in V2 and placed it under Layer 0. Then I chose the Eraser tool. I selected a large, 100-pixel soft brush and entered 15 in Opacity field. I brushed in some extra density in the window and in the light cast from the windows. I did the downstairs window, and then I added a little density to the rail in the front of the shot. I used a smaller brush for the rail. All of this could have been done with the Burn tool, but using Layers is the only way to solve problems in some shots. I flattened the image and labeled it V5.

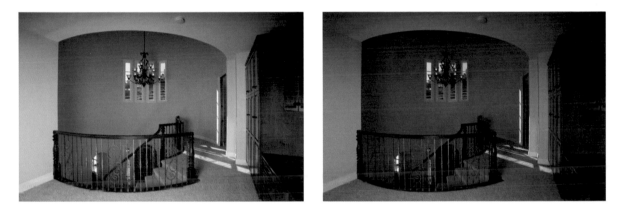

Left—V1. Here is the image with the basic corrections I made in Camera Raw. Right—V2. I made this shot 1.5 stops darker in Raw. I'll use this file to put detail back into the highlights.

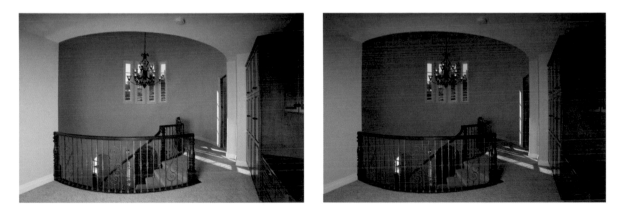

Left—V3. This version is a stop and a half brighter. I'll use this file to lighten the shadows. Right—V4. The tungsten-balanced version will clean up the color on the chandelier.

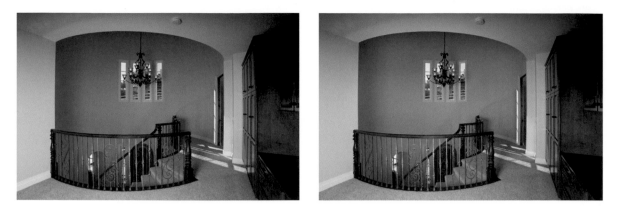

LEFT—V5. I used V1 and V2 to make this version of the image. As you can see, the bright areas have more detail. RIGHT—V6. In this shot, the shadows on the back wall are lighter. This is a combination of V5 and V3.

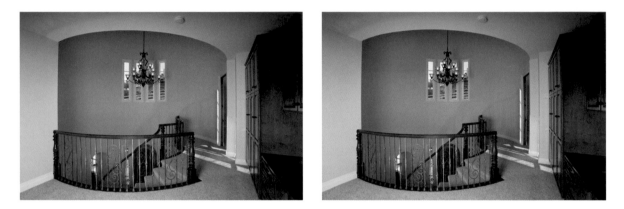

LEFT—V7. Here the chandelier is brighter and the color is bluer. I wouldn't want this to be a really white light, but I did want it to be whiter. RIGHT—V8. I fixed the broken bulb in the chandelier.

I did essentially the same thing when I dragged the lighter version, V3, into the image, placing it behind the combined V1 and V2, now called V5. In this case, I used the Eraser tool with a 1600-pixel brush to lighten the back wall of the shot. Then I took the brush size down to 600 and softened the shadow at the left side of the back wall and along the top edge of the curve. I also reduced Opacity setting to 10%, as this needs to be a subtle correction. I flattened the two layers and named the image V6.

The last layer was the one with cooler light (I called it V4). Using this layer allowed me to clean up the color in the chandelier. I put the blue layer under the V6 version of the shot. Of course, the first thing I did was to zoom in the chandelier, to make it easier to work on. One of the great things about working this way is that all the layers are versions of the same file, so everything lines up. If I had shot a second version of this image, with a blue filter, the chandelier might have moved. I tried to stay inside the glass

shades, but as I was using a soft brush, it wasn't critical. I had to raise the Eraser tool's Opacity setting to 25% to get the effect I wanted. When everything looked right, I flattened the image.

You probably noticed that there are other things wrong with this image. One of the most noticable issues is that one off the lights in the chandelier is out. I selected the light from below and to the right (I used the Lasso tool and worked just inside of the shade I was copying) and copied it onto the dark shade. When doing this, it is important to feather the edge so that it will blend with whatever you are copying onto. I flattened the image and saved it as V8.

This shot has a small amount of barrel distortion, and the perspective is very slightly off. You will want to correct for barrel distortion before cropping the image, as the correction works from the center of the shot. Simply go to Filter>Distort>Lens Correction. In this case, I used a correction of 3.5 in the Remove Distortion field. As you work with your lenses, you'll notice that this correction doesn't vary by much for images made with a given lens, but it will vary between lenses. You can see how the lines bow inward in the image below.

I used the Crop tool, with the Perspective box checked, to straighten and crop the image. Since the Lens Correction filter had already been applied, the image didn't require much straightening. Next, I slightly sharpened the shot. Then all I needed to do was clean a few spots and get rid of the smoke detector. I made quick work of this and saved the final image as V9.

ABOVE—Screen 2. The Lens Correction filter allows you to correct for barrel distortion.

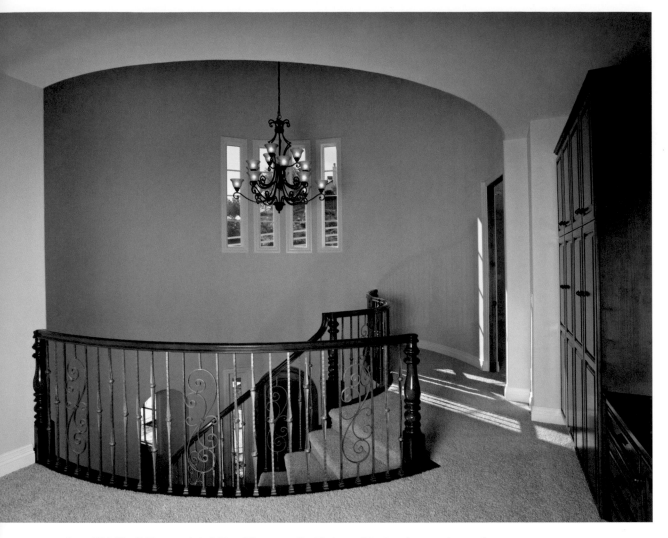

ABOVE—V9. I did a slight crop and straightened the perspective. The image did not need very much correction.

HDR Images. As I mentioned earlier, I made an entirely separate series of images at this site so that I could use the various exposures to create an HDR image. I didn't use any lights for this series.

HDR imaging can be magical, but the results are not always predictable. The process entails merging multiple versions of the same photograph, made with different exposures, to increase the amount of visual information in the shot. This can be done in Photoshop (go to File>Automate>Merge to HDR), but it does not offer as much control over the process as does a program like Photomatrix, which is designed specifically to handle this task.

For the purposes of this book, we'll use Photoshop to create the HDR image. You can choose files or folders. Because all of the files I was going to use were in one folder, I choose that option. You can also choose to work with RAW files or JPEGs. Since the RAW files have more information, I will work with them. If you want to adjust

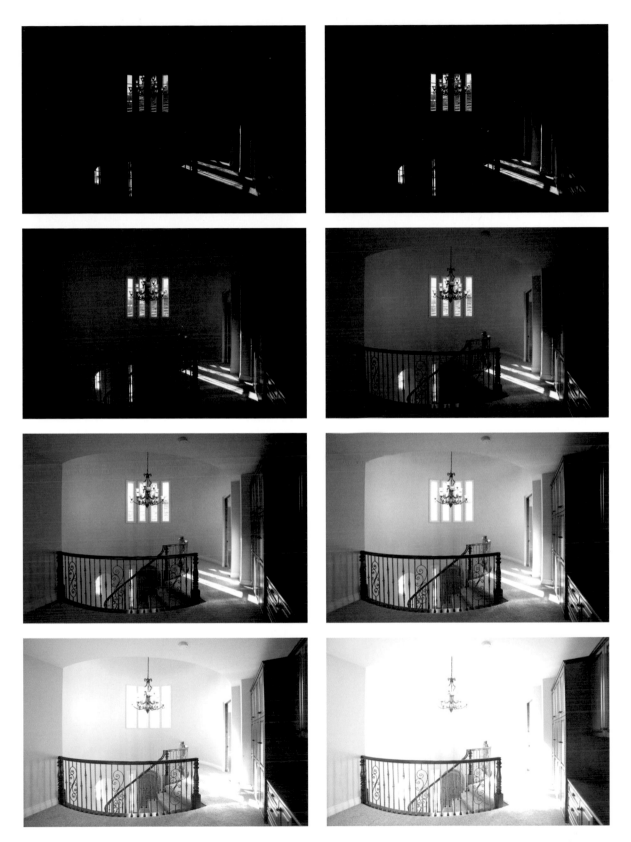

ABOVE—This is the series of images I used to make the HDR file. The camera was stable, so the images are in register. Of course, I used the RAW versions of these files.

the color of the image in Camera Raw, it might be best to convert the color and then make 16-bit depth images of the files. Unfortunately, the HDR conversion won't recognize color changes to the RAW files. I had eight images in that folder, which covered an eight-stop range. All I had to do was choose the folder and wait. Since this takes considerable computing power, you may need to wait a while. (I should add that you can also choose to have Photoshop align the images. If you were very careful to keep the camera in one place when you shot, you won't need to do this. If the camera moved even a little bit, select the Alignment option. Note that this will make the processing take even longer.)

The first option is to set the white point. This is basically an exposure correction. You can move the slider until the balance of the shot looks right. I moved the slider to make the shot a little darker. In earlier versions of Photoshop, there is little or nothing that you can do with the 32-bit depth version of the image that Photoshop

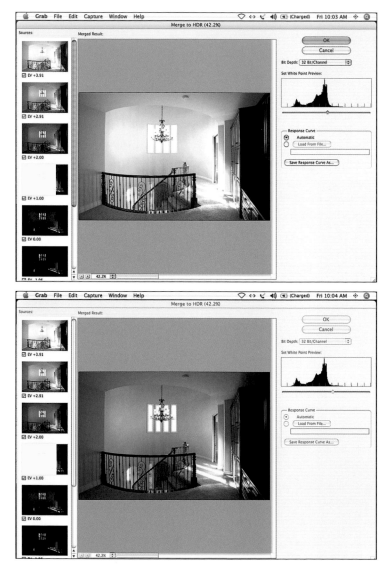

TOP—This is the HDR screen in my version of Photoshop. As you can see, you can adjust the white point of the image. BOTTOM—I used the adjustment to make the image darker.

created. In later versions, you can do corrections like Levels for the image. Here, I used Levels to try to get more information in the highlights. I thought the shadows worked well at this point. Finally, I converted the shot to 8 Bit/Channel under Image>Mode. In the HDR Conversion window that appears, you can make adjustments to the Exposure and Gamma (contrast) sliders. I made minor adjustments to lighten the shot and

to reduce contrast. I then sharpened the 8-bit image. I would also fix the shade once the image was converted to 8 bits.

I think that both versions of this shot are usable, but I would always pick the version done with strobes. I prefer the look of the windows and the shape of the room.

Layers. There are other things you can do with Layers. One of my favorite uses is to fix reflec-

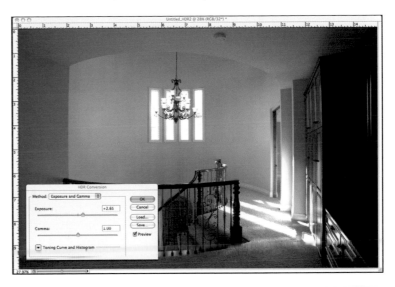

Top—This is the control for converting from 32 Bits/Channel to depth to 8 or 16 bits. You can also adjust the Exposure and Gamma. Bottom—Here is the shot after it was converted to 8 bits.

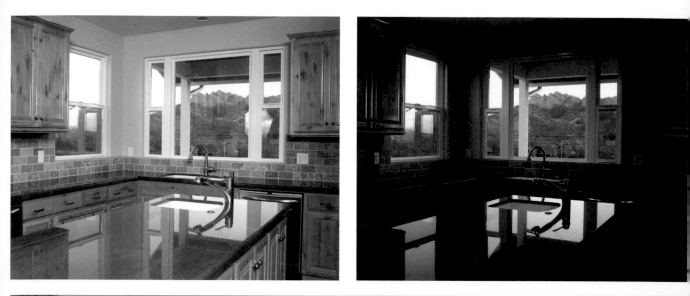

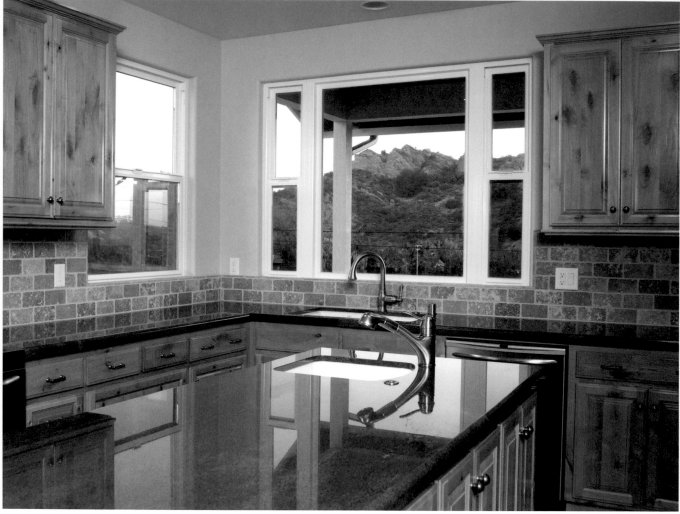

FACING PAGE—(top left) You can see the umbrella on the right side of the window. (top right) This shot was made without strobes, so there is no reflection. (bottom) The two shots were combined and the reflection was removed.

tions in windows. If you're shooting tethered to a laptop, you'll see the reflections in the windows in your test shots. Of course, some of the time you'll be able to fix this problem by moving your strobes. Unfortunately, that will often cause other problems, so it is great that there is a simple fix for windows. Shoot two versions of your final setup, one with the strobes on and one with them off. You can place the version without strobes behind the strobe version in Photoshop's Layers, then you can use the Eraser tool to remove the reflection or select and delete that part of the file. I used the select-and-delete method in the example shown on the facing page.

You can't do exactly the same thing with a reflection inside a shot because, without a strobe, there isn't any light (or isn't much light) on the subject. You can move the lights between two exposures and put them together to hide a reflection, but you can usually find a single place for your lights and fix any problems with the Clone tool. This is certainly easier than lighting the shot twice.

A Simple Fix. Finally, I want to show you one more example of how the Lens Correction filter and the Crop tool's Perspective option can work. This image has more problems than the previous example. You can see how much barrel and perspective distortion you can fix with these tools.

Photoshop is an essential part of our tool kit. It can provide multiple pathways to improving your image. If you haven't spent much time perfecting your skills with this program, I hope you will make it a priority.

TOP—This image suffers from barrel distortion and perspective problems. BOTTOM—The Remove Distortion setting had to be pretty high to straighten the lines in this shot.

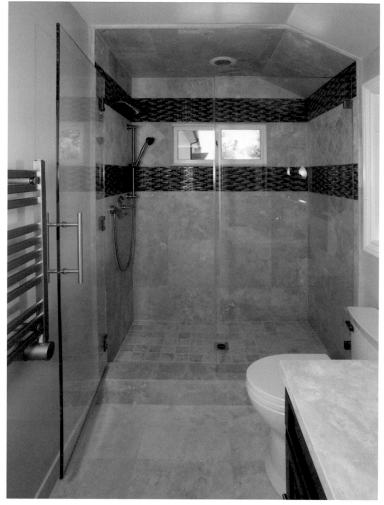

LEFT—I used the Crop tool with the Perspective option turned on to fix the angles in this shot. RIGHT—I think the corrected version of the image looks much better!

7. The Clients

Getting business might be the hardest part of doing business. I don't have all the answers, but in this chapter, I will recommend some strategies that seem to work well now for getting clients and getting the job.

ENSURE A GOOD FIT

The first thing you must determine is who you are going to do business for. While you might be skilled in a number of different types of photography, no one is skilled at everything. If you do an honest inventory of your skills, it will help you to find clients who are a good fit. At the same time, you should look at how businesses use images: advertising, web sites, annual reports, documentation, and so on. Remember that you are a resource to a business. It is better if you can be an *expert* resource.

Below—This is the kind of simple shot that might be used for a real estate sale.

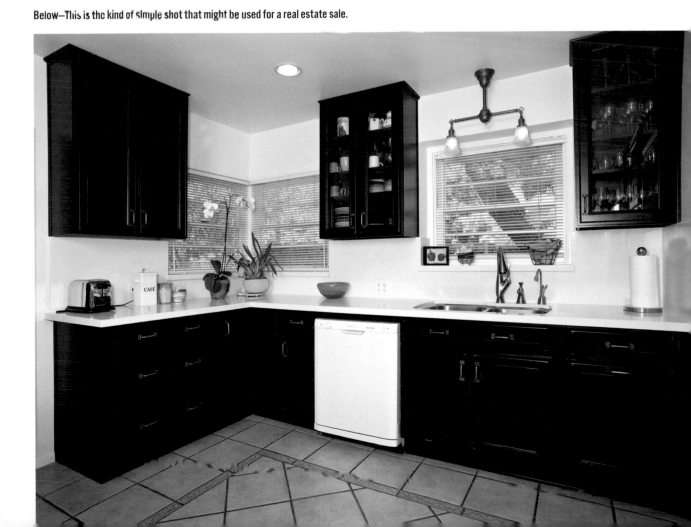

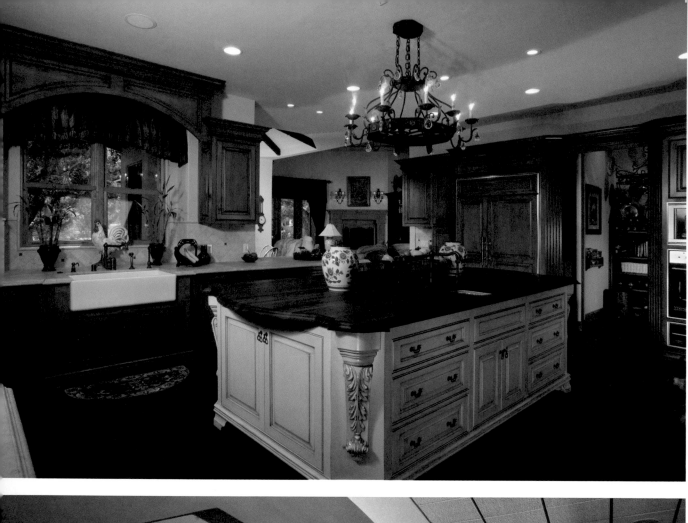

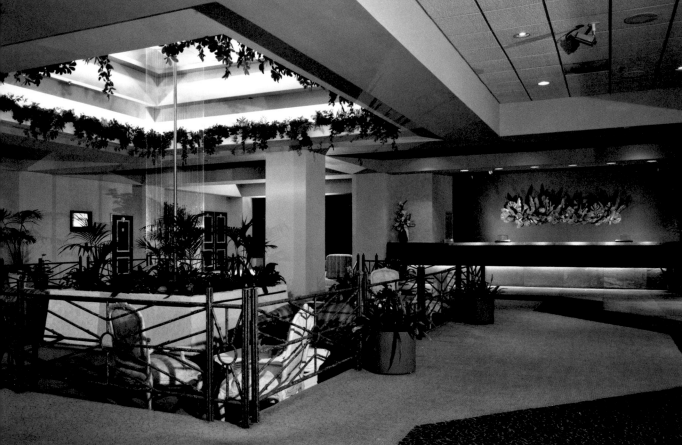

Facing page—(top) Designers often want to have everything in the shot. This can make a shot look really busy, as the photo is so much smaller than the original room. (bottom) Hotels are really fun jobs. The clients are usually good to work with and you have a variety of challenges: rooms, lobby, and restaurants. Right—Architects and designers often finish their part of the job a long time before the job is finished. Sometimes you need to remind them to photograph their work.

POTENTIAL CLIENTS

Some of the potential clients for interior photography are listed here, in no particular order.

- Real estate agents use more interior images than any other sort of client. Unfortunately, they are less concerned about quality than they are about price. It is unlikely that you will get good jobs unless you are shooting very expensive properties.
- Hotels are my favorite clients. They need good work and appreciate what it can do for them. Sometimes offering to do part of the job as trade can help you secure the job.
- Architects are usually finished designing a job well before it is built, so you have to remind them to shoot old work. Work for an architect can often be sold to the contractor and other people involved in the finished project.
- Interior designers can be difficult clients. They often want to have everything in the shot and are disappointed when they can't see the details. It is important to involve them in making decisions about the shot, particularly by shooting tethered to a laptop.
- When I look for new clients, I look in all the building trades: contractors, masons, cabinet-makers, and so on. I also look at the businesses that make building supplies. I got a lot of work from a client that makes concrete dye.

- General contractors can be wonderful clients. They can create regular work and will often give you opportunities to work with the subcontractors.
- Restaurants usually need shots of patrons and food, in addition to interiors, so it is good to be prepared.
- Health clubs, retail stores, and museums make good clients.

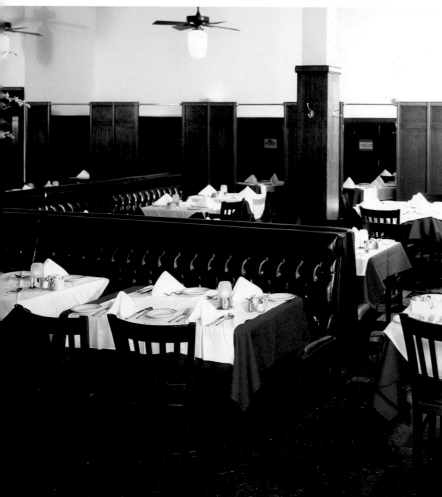

ABOVE—One thing about working for general contractors is that you shoot empty houses. Look for ways to make the space interesting. LEFT—Restaurants often need you to work when they are closed. Still, they can be very satisfying jobs.

You should use the Internet to browse the chamber of commerce web site and do some business searches. You should also check out the phone book. Collect information about prospective clients as you do this—particularly street, e-mail and web site addresses, and contact names. Your clients are not going to find you spontaneously. You have to do the work to find them.

PASSIVE ADVERTISING

The Yellow Pages. The Yellow Pages used to be a very important part of my marketing. I don't advertise in them anymore. In my market, Los Angeles, the Yellow Pages are useless for com-mercial photography. They may still work in your market. See who is advertising in the pages and how big the ads are. Yellow Pages ads are expensive, and they bill you even if you don't get clients.

Portfolio Sites. There are a bunch of these sites (e.g., goportfolio.com and portfolios.com). I am not sure if any of them are worth the time spent uploading to them. Behance is worth checking out (www.behance.net) because you can link it to pages at LinkedIn (a business networking site), Facebook, and Twitter. Currently, Behance doesn't have any size limits, and you can send out a personal page as e-mail.

BELOW—Retail clients can be very good, especially if they have multiple locations.

Bidding Sites. These are sites that companies and people list jobs on. You enter a bid. For most jobs, the work will be done inexpensively overseas, but occasionally a local job comes up. Check out guru.com and getafreelancer.com. I have gotten work off of one of these, but rarely.

Craig's List. It doesn't take a lot of time to place an ad on Craig's List. I have one at my FTP space that I post to the list. I have gotten a number of jobs from Craig's List, and it's free, but you have to re-post your ad frequently.

ACTIVE ADVERTISING

HTML e-mail. This is one of my favorite advertising methods. Use all those e-mail addresses you collected and send them an e-mail formatted to look like a web page. You can send an e-mail with the pictures where you intend them to be and with live links to your web page. HTML mail is a great way to promote yourself. You need to know how to do web coding, or get someone to create a page for you. If you don't want to do your own coding or your ISP doesn't allow mass mailings, you can turn to companies such as Mail Chimp or Constant Contact, which are quite easy to use. It is also possible to use Behance for e-mail promotions.

Social Networking. Having a Facebook presence probably helps a lot with getting weddings. I think it is much less effective for photographers looking for commercial work. I am on LinkedIn, which is a business-oriented networking site. I think a key is to update your profile frequently with material related to your work.

Live Social Networking. Attending business mixers and joining trade groups can help you get work. The local chamber of commerce is a good place to go. You may also get work from other

I provide technical writing skills, particularly about photography. You can see samples. In addition I teach on-line photography classes: Introduction to Lighting, Portrait Lighting and Commercial Photography. Please contact me for your next project!

ABOVE—This is the kind of e-mail I send to clients. Each e-mail contains live links to my web site and my online classes.

photographers who don't do commercial work, so consider joining a photo group. You might also see if there are any graphic design or advertising groups that you can join. It is useful to have large display prints to share, and a Power-Point presentation can be effective.

Referrals. Adding interior photography to your repertoire is a good way to increase your profitability, especially if you often photograph events. The contacts from event photography can get you architectural jobs, and shooting interiors can give you work during the week. Eventually, the contacts you make when shooting architectural jobs may lead to booking more events. If you do interior shoots for a restaurant, for instance, they may refer you to a party.

Postcards. Probably the best thing you can use as direct mail piece is a postcard. They can be expensive, but they are definitely worth considering. Check out Modern Postcard and Zoo Printing. You can also make postcards with an inkjet printer, but this is a lot of work and your per-card costs are much higher than if you used a commercial printer. When I send cards, I generally show that I do several types of photography. You want a card to appeal to a broad market, as you don't know where the card will end up.

Cold Calling. Frankly, I hate doing this. No one likes to receive cold calls. But, at ad agencies and other places where they buy photography, it is somebody's job to talk to you. If you do this, remember that your call may not be important to someone. Get off the phone before you annoy someone unnecessarily.

Visiting Clients. This can work if the circumstances are right. For instance, if there is a convention of your target clients, you can attend, pay a visit to prospective clients, and hand out your cards. In Los Angeles, there are several places where the people in certain businesses are located. So there is a fashion district and a place where home designers are located. If you walk through and hand out cards, you might find some work. Have a portfolio with you. Of course, basic politeness should be observed.

COMMUNICATING WITH CLIENTS

Architectural photography is typically client-driven, meaning that you will find yourself working for a client. Once you've reviewed the space, you'll want to communicate with your client to determine how they see the space. Be aware of any aspects of the interior that are especially important to your client. An interior designer may see a room differently than would a painting contractor.

In this line of work, good communication skills are critical to your success. To ensure that your clients are satisfied with your product, you will have to make sure they understand what can be done and what choices will need to be made. For example, when you look at a room, you see everything life size. It can take a minute, or several minutes, to see everything in the room. Clients frequently want to see the whole room in the photo, but they don't realize that the details will not "read" well in an image, which, by design, is so much smaller than the room is. Your client will also need to understand that the end

BELOW—This is a postcard I used for contractors and designers. It was moderately successful.

use of the image will greatly influence the design of the shot. They will need to understand that more of the design of the room and the details they have carefully selected will be discernible in a two-page magazine spread than in a 4x6-inch image made for their web site.

When I shoot an interior, I tether my camera to a laptop. This makes it easier to evaluate my shot and to discuss the overall design of the shot with a client. A good architectural shot will evolve as you create it. Your client can be part of that evolution. If you start discussing detail and usage at the beginning of the shoot, you will find it easier than if you bring it up in the middle of the shoot or after you're through shooting.

THE DETAILS OF THE JOB

Here are the elements that you and the client need to agree upon before a job starts:

- what you are going to photograph
- what you will deliver to the client
- when you will shoot
- when you will deliver
- how much you will be paid
- how you will be paid
- what happens if things do not go well
- who owns or controls the finished images

You can get a pre-written contract from photographers' organizations that will define some of these matters. Often these contracts outline high fees for things like weather delays and late schedule changes that may make your client choose another photographer. I prefer to write a custom agreement, which I generally refer to as an estimate. It will define the nature of the job, the conditions, and the costs. Defining ev-

erything before you start to shoot will create a much better business relationship with the client. This document should also specify a deposit for the job, so you'll want to get it to the client as soon as possible. You can use this document like a checklist when you start to shoot.

Most clients think they are buying photographs or digital files. The truth is, as photographers, we are selling our time. That means our expertise, the use of our equipment, and the hours spent pushing the shutter button. Ensuring that these issues are addressed in your proposal will help clients understand that your fees cover more than simply pushing the shutter button and delivering their prints or image files.

It is also important to emphasize that a lack of preparedness on your client's part can be a budget buster. I did a job for a hotel in Beverly Hills few years ago that was a nightmare. The graphic designer, who commissioned the job, was an hour late. The owner of the hotel hadn't prepared. They left to go shopping for flowers, a two-hour delay. The designer hadn't confirmed with the client a day before the shoot, so always confirm.

Here are some other points that should be addressed in your estimate:

- Who is doing the job? Who is the job for? Who will be paying for the job? I am very careful to put all the client's contact information on this document.
- What is the job? Say the client needs five shots of a restaurant and bar. I want to know how many angles I need of each room. Am I shooting five shots or twenty? The kind of lighting and windows might affect my estimate, but it probably won't be written into

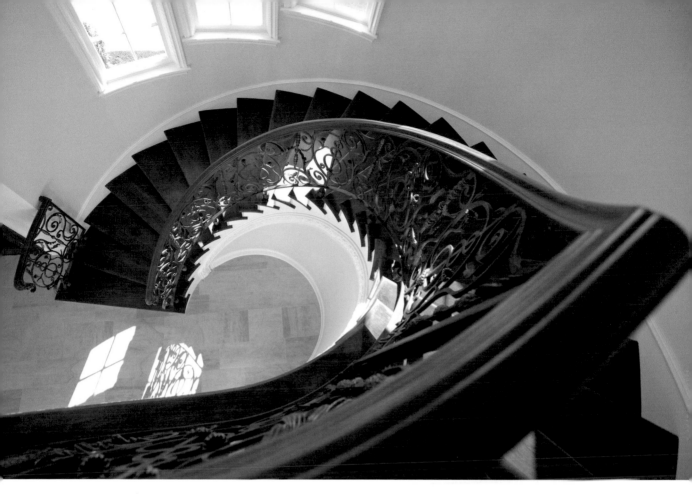

Above—This shot was made for a contractor who builds staircases. The unusual angle makes the image more effective.

the proposal. I want to know how the shots will be used, and I will specify this in the proposal. If the client comes back later and complains that the shots don't look good in another usage, I can refer to the proposal. I may give the client a price based on an hourly rate or on a day rate. If I think the client will add things to the job, I'll go with an hourly price. That way I'll get additional payment if the job runs long. If the client only needs the shot for the web, I may be able to do the job quicker than if the image is needed for a magazine. Regardless, I need to define the job. I need to know what size and quality of file the client needs. I need to know if the client expects the RAW files, JPEGs, or will need to have postproduction work done.

• The date and time of the shoot are critical. You *must* arrive at the time you stated. You need to tell the client how long you will be unloading and setting up. The client should understand at what point you expect to begin billing. I generally bill for setup time but not for packing up. I don't want to have to rush packing because of the client's budget. If the client wants to reschedule I will do so, with no additional cost, with 48 hours' notice. Photographers sell time. So the contract should specify costs and responsibilities for rescheduling and weather delays.

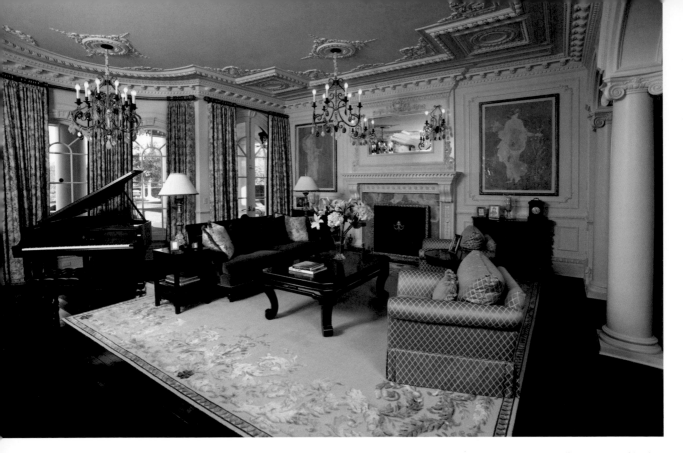

ABOVE—This shot has a remarkable amount of detail. In a large photograph, some of that will come across, but as a small image, everything just blends together.

- Arrange the date you will deliver. This is important to the client, so be responsible. If there is a problem, communicate with the client as soon as possible.
- Specify how much you will be paid and in what manner. In general, I get a deposit before session starts. Remember, you are doing custom work; you can't sell restaurant shots to another restaurant. Determine when the balance will be due. Most businesses can cut a check in less than two weeks. A really large business, say Disney or General Motors, will have a program for payment. There is no reason why you shouldn't be able to find out what this is. With a large business, bill exactly the way they tell you to. Purchase order numbers are very important.

- If things don't work, say the client isn't ready when you get there, they should know approximately how that will change the price. Some days I have problems, too. So I tell the client that if the work is not usable ("usable" is defined as: did you use it?), then I have the option to redo the shoot or refund the client's money. I will specifically state that I am not liable for costs incurred in setting up the shoot. The most I will refund is the deposit. This hasn't happened very often. When there has been a problem, it is usually because I didn't define the job well.
- Ownership details must also be addressed. What can your client do, and what can you do, with the images? Very large companies often dictate this, but it is generally negotiable.

ABOVE—Here, the room is really just a background for this lifestyle shot. You often need to light a space to create an image that tells a specific story. This shot was made for a small winery,

Most of the time I want my client to have the right to reproduce the images in any way they wish, except selling the images as images. This means that the client can use the images to promote the business in print or on the web. After all, I want them to be successful. But if they sell the image to a sub-contractor, they must pay me. So, if I do a construction job

for a general contractor and the client wants to sell or give the image to the cabinetmaker, I should get paid. I want to retain the right to use the images for self-promotion, and any additional sales, so I can sell to the cabinetmaker. Often the client will want to make sure the images are not sold to his competitors, and this is reasonable. Though I may have certain ideas about ownership, I am negotiable about this, as I want to do the work.

Obviously, there may be other issues specific to the job. The key thing is that I want to work and the client wants photos, so we should be able to make a reasonable deal.

I am not a lawyer, and I can't give competent advice about how to collect from a job gone bad. My experience tells me that giving the client a clear, honest estimate reduces the problems that might occur in business. When I get a deposit, I know that the estimate has been accepted. I also know that the client is acting honestly. Most of the problems I've had came from clients that didn't give a deposit. I use an invoice from an accounting program to request the final payment for most clients. If the client is a very large business, I will follow their billing practices. Of course, it is possible to create a more complex business practice, with delivery forms and so on, but I am not sure that doing so makes business more secure.

PRICING

There are several factors that should affect pricing. The first is how much experience you have with the work you're doing. In the beginning, you will probably take longer to complete a job and may not do as competent a job, so you should

BELOW—This room is very dramatic. Because the scene was shot with a wide-angle lens, the staircase is actually a little more dramatic in the image than it appears to the naked eye. Lights were placed on both floors and at the back of this room, so this shot took some time to set up.

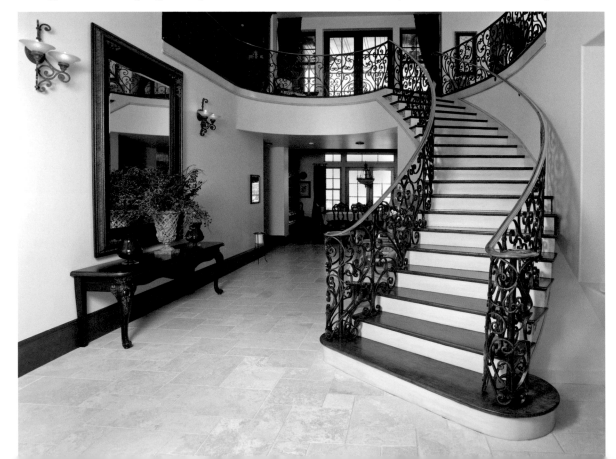

SAMPLE ESTIMATE

John Siskin
123 Professional Blvd.
Richman, IA, 12345
(123) 456-7890

Dear Ms. Client,

Thanks for speaking with me earlier today. I would be very pleased to work on your upcoming project. As I mentioned on the phone, most of my time is booked very close to the time that my clients need me. I had a chance to look at your website, and your product certainly works well in the commercial locations.

DESCRIPTION

Photographs of set-up product on location at address. I will be at the site at 10:00AM. It will take me about 30 minutes to set up. I will shoot several angles of the product—with and without people. There will be approximately 15 final images. All usable files will be delivered to the client. A smaller set of files will be produced with additional Photoshop work, and this set will also be included. I expect the shoot will take about 4 hours. I understand that this job is going to be used for a $^1/_2$-page magazine ad but may be used in other situations also.

SHOOT FEE	$000
ASSISTANT FEE	$000
POSTPRODUCTION FEE	$000
TOTAL	$000
DEPOSIT REQUIRED	$000

All work will be available to your company to use as you feel appropriate to your business needs. I would appreciate copies of any print advertising done with my work and links to online usage.

If you need to cancel or reschedule this shoot, and can do so at least two days before the shoot, there will be no charge. For cancellations or rescheduling with less than two days' notice, there are additional charges.

Thanks for calling me with this opportunity.

John Siskin
www.siskinphoto.com

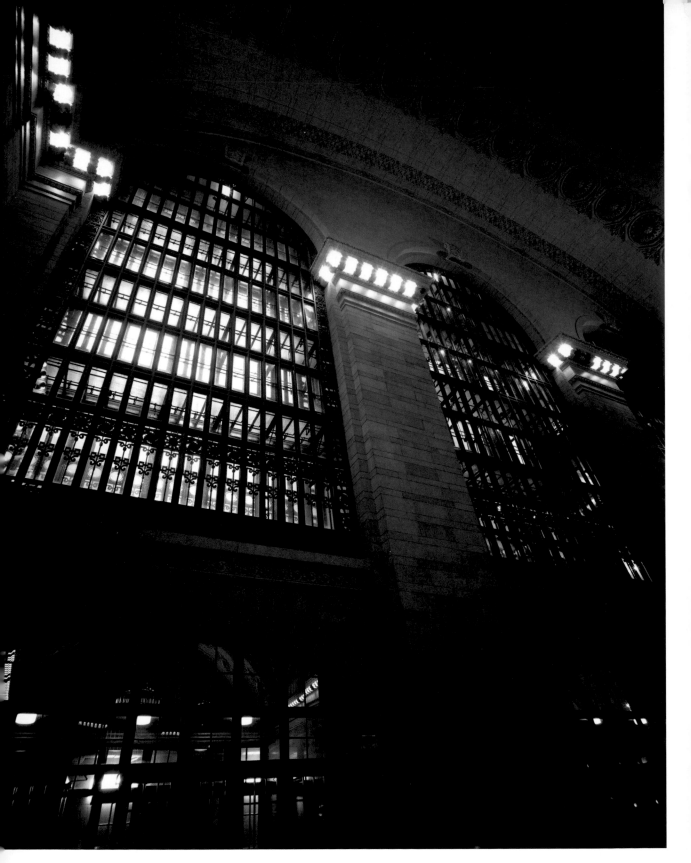

ABOVE—I really like the long tonal range created by the windows in this shot. This is Grand Central Station in New York. I like this angle because it makes the windows look monumental. FACING PAGE—I like to shoot some buildings as art rather than for business. I took several different views of Grand Central Station. Generally, you need permission to shoot in a place like this, even if it is in public. I usually shoot fine art images in black & white.

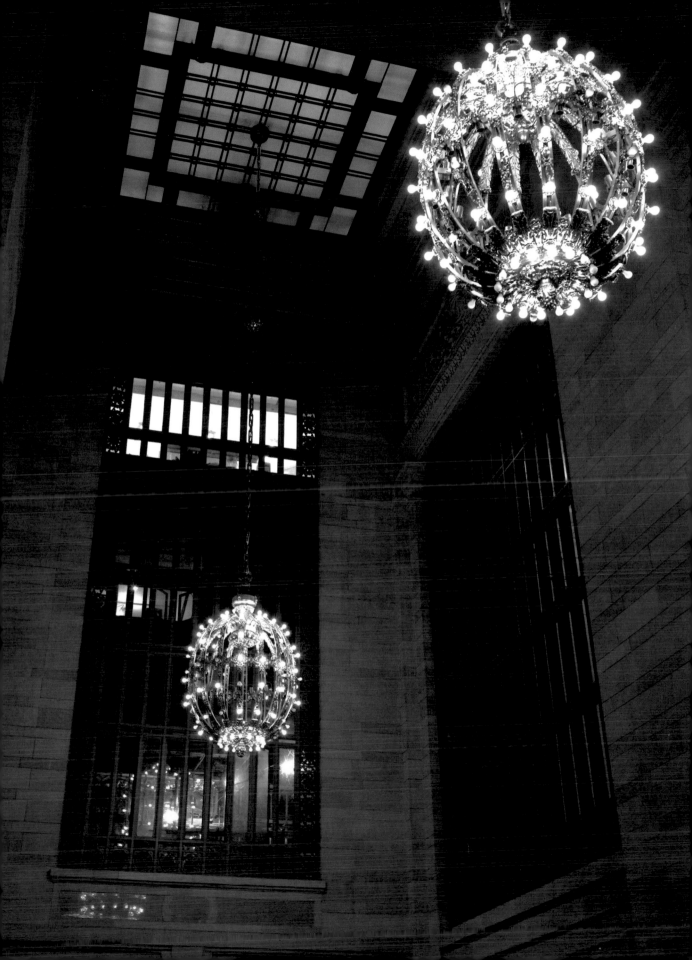

charge less than your competition, or you won't get any work. As you gain experience, you will be able to figure out about how much work a job will require and what you want to earn in a year. If you expect to do eighty jobs and earn around $80,000, you'll need to get about $1000 from each job. Of course, the market in your area will also give you some idea of what you can charge.

When you bill for your time, you can specify the cost for the whole job or break the rate down to show your prices for the various parts of the job (e.g., shooting and postprocessing). You may also bill for prep time, but that doesn't come up much when I shoot interiors.

When I shot with film, the expenses were a very significant part of a bill. Four-by-five inch film, Polaroid film, and processing could add up to a couple hundred dollars. Digital expenses are, of course, much less, but they could involve media costs, location costs, assistants, and expendables like filter material and seamless paper. The assistant's fee is often the only one that is significant. If the client wants to discuss my use of an assistant, I point out that I get a lot more done if there is someone to lift and tote things. Once the client sees how much gear is involved in their shoot, this is rarely an issue.

These costs and the applicable sales tax should go onto the estimate. Usually at the bottom of the page, I'll add "Request for Deposit" of XX (usually 50 percent) by a date, often two days before the shoot, to keep the dates scheduled reserved.

Making a clear presentation for the client will create trust and respect in your relationship. If you are too casual about this, you will lose jobs and have problems with the jobs you get.

LEFT—There is a nice balance between the strobes and existing light in this room. You can see out of the windows, and the room lights look good. RIGHT—This is the entry of a new home. The low angle defines the height of the entryway effectively. This was a difficult angle to shoot due to the many interesting aspects of the room.

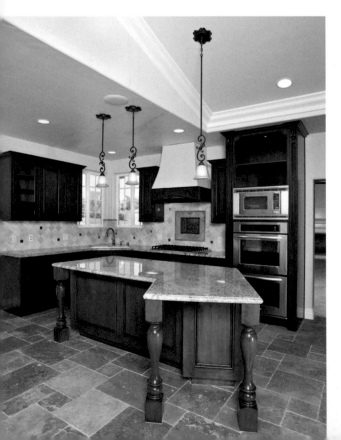

The Portfolio

In the first part of this book, you learned how to use the tools of the trade, how to find and communicate with clients, and how to address common image problems in postproduction. In this section, you will study some of the images I've produced for real-life assignments. You will also find a helpful discussion about each shoot that shows you how the images were conceptualized, shot, and finished in postproduction.

Prelude to the Portfolio

I have been making photographs for more than forty years (I started early). From the beginning, I have created photographs to show other people. Photography is a method of communicating, and it is also a sort of individual memory.

One of the most important things that photographers do is enable others, like clients, to communicate at a higher level. Whether a contractor is showing his projects using 4x6-inch prints or a large portfolio online, I know that good

BELOW—One other way to shoot an interior: remove the roof! I might show this piece in a fine art portfolio, but not to a contractor.

photographs will help the business to get more and better jobs. People who show junk photos earn less money. So our goal is to give client the tools that will help them to communicate better.

In order to do that, we have to represent ourselves well and also represent the kinds of products that we can give the client. I can give the client 20x30-inch prints of their project. I can give them mounted 11x14-inch prints. I have several clients who do books of their finished projects, which they show to their potential clients. Of course, I can give a client images for a web site or magazine ad. So when I call on a new client, I'll bring a variety of samples, not just different shots, but also different presentations. I often show large prints (16x20 inches) to clients. Many clients create large things like buildings, so small images just aren't as effective. When I make a presentation in front of a group, I always use large prints. I may also use a PowerPoint presentation, but I think the big prints are more effective.

I have created many portfolios over the years. I've designed each one so that it can be customized to a specific client. I may have forty prints in a group, but I will actually choose twenty that are best for the situation I'll be in. I have some fabulous dog pictures, but I don't show them to an architect.

In the balance of the book, I will present eleven images that clarify the ideas I've already introduced. These images aren't all personal favorites, but they enable me to discuss how the work is done and how problems are addressed.

Ridge Top

In this room, there was a lot of ambient light coming from the many windows. I needed to balance the ambient light with the strobes. The challenges included the large area of the shot and

the very dark floors. It was difficult to get the light on the stainless steel refrigerator and other appliances to work well. So this shot presented challenges in both the capture stage and in postproduction.

You can see how the flowers on the kitchen island draw the eye in the initial capture. It is often difficult to get clients to understand that a picture of a room is smaller and so details are perceived differently. For instance, a lot of small objects will not be seen as individual things, but as clutter. The flowers had to be removed.

The kitchen had interesting light, but the rest of the shot was much too dark. I had already placed a light in the hallway and there was another light behind the windows on the left side.

I started with one 60-inch umbrella near the camera, but I didn't like that because I needed more power behind the short wall. You can see I also had problems with the way the ceiling looked.

In the third image (facing page, top) I put two umbrellas, one on top of the other, near the camera. This softened the light and provided additional illumination, since I had two

Top—Not enough light was used to create the first image. The shadows keep you from seeing most of the room. Bottom—I placed a large umbrella near the camera, which helped quite a bit.

Top—I moved two umbrellas near the camera and put the large umbrella behind the short wall. Center—All seven lights were used in this version. Bottom—You can see the light placement here. The light behind the short wall is at 400 watt-seconds, and the one behind the island is at only 50 watt-seconds. The rest are at 200 watt-seconds.

200 watt-second strobes. Then I placed the 60-inch umbrella on a 200-watt monolight behind the wall near the ceiling. You can see that the light has a much better balance. In addition to the lights behind the wall and near the camera, I have a light with low power (50 watts) behind the island. I needed to create some additional highlights in the appliances and pantry door. While the light from outside created some bright areas and a shadow of the fan, I needed it to open up the living room. One more thing: note that there is detail in the floor. That was an important feature of the room.

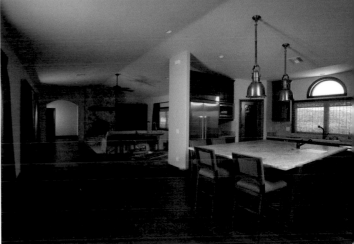

I made a lot of little adjustments to produce the fourth image (right center). I removed the lamp and whatever was next to it. I increased the power on the monolight behind the short wall. The exposure was f/9.5 at $^1/_{10}$ second and the ISO was set to 100. I increased the shutter speed in this version to open up some of the shadows. You can see how that also made the windows lighter. I like this shot, but I think there are some things that can be improved with Camera Raw and Photoshop. First, let's look at the way the lights were set up.

I used two 30-inch umbrellas to modify the lights. These don't have black backs, so I can use them as a shoot-through source (as I did behind the island) or as a reflector (as I did in the hallway). Actually, I think the umbrella in the hallway gave me some bounce from the shoot-through side, which probably made things

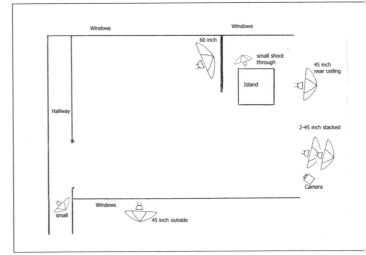

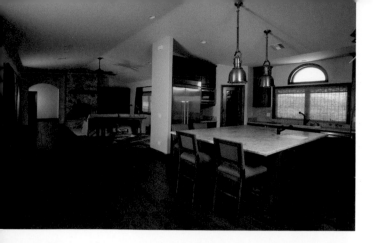

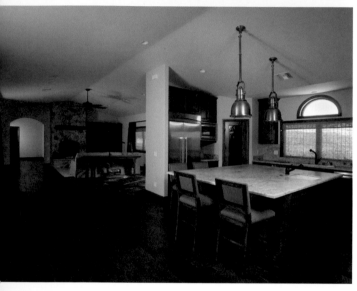

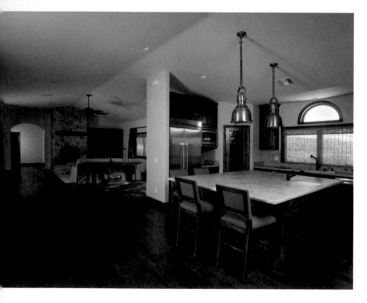

Top—The Fill Light slider and Recovery slider helped to even out the exposure a little more in this version. Center—This is the final cropping, but there is more work to do. Bottom—Just a few fixes: dust, noise, and the color near the window.

better. I also used four 45-inch umbrellas—two near the camera, one outside, and one in the kitchen. I had a 60-inch umbrella hidden behind the wall in the living room.

When I first opened this file in Camera Raw, I could see a few things I wanted to do. I warmed up the temperature a couple of hundred degrees Kelvin, and I set the Saturation and the Vibrance values a little higher. I set the blacks to 1 instead of level 5 (the default setting in Camera Raw). Next, I used the Fill Light slider to open up the shadows and allow for more detail in the dark wood. A setting of 15 worked nicely. I also adjusted the Recovery slider to 19. This made the half-round window in the kitchen look better. A too-high value for the Recovery slider made the ceiling look bad. See the image at the top of the page.

To improve the ceiling, I selected the Burn tool, chose a broad brush, and set it to Darken Highlights. I also darkened the half-round window in the kitchen. I used the Crop tool with the Perspective box clicked on. First, I wanted to get rid of the cords on the right side of the image. I also moved in a little from the top and the right. I straightened the perspective on the right side. The result is shown in the left-center image.

My camera wasn't doing me any favors on this shot. You can see a red sensor reflection near the round window in these shots. Also, there were a couple of dust spots on the sensor and a fair amount of noise in the darker areas of the shot.

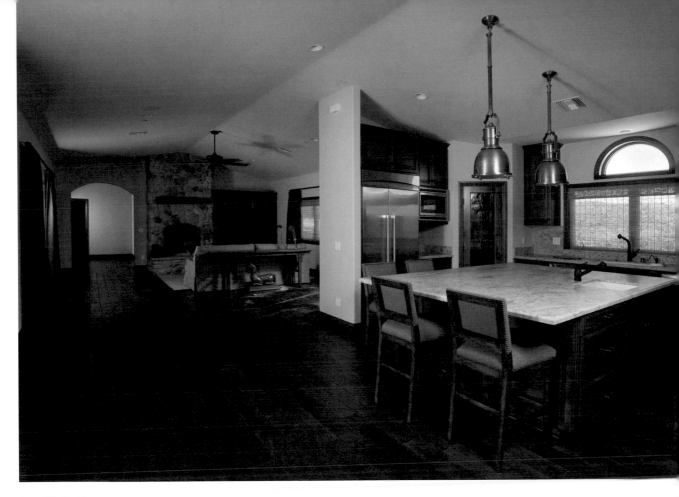

Above **The final image.**

I removed the red saturation near the window, used the Healing Brush to remove the dust spots, then used the Reduce Noise filter. Finally, I darkened the highlights on the refrigerator a little. I also opened up the shadows in the window in the pantry. I used the Burn and Dodge tools for this because it wasn't a large area. I often use the Clone tool to accomplish something similar.

I think the final image (above) works well, but getting the shot right required a lot of lights and some postproduction work.

Stage Road

This shot really helped to create an important relationship with a client. The construction had just been completed, and the house was empty, but the way the angle defines the staircase and the door frame really gives the shot a sense of drama and completion. I have gone on to do thousands of images for this client.

In the first image (below left), I had the camera a little too close and used just ambient light.

None of the important aspects of this shot had enough light. You can see that the windows contributed a little light, and there was light on the entry.

In the second version of the image (below right), I had a light illuminating the outside of the doorway, but it was too hard. A light with a small modifier (like a 30-inch umbrella) or no modifier produces hard light, which throws

LEFT—This is the image at the beginning of the shot. RIGHT—The lighting is better, but not even enough. Also, I don't like the highlight on the right side of the doorway.

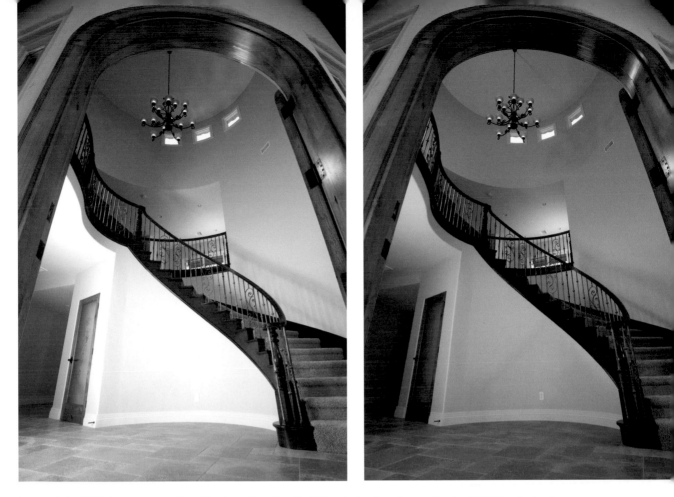

Left—I added a light inside the doorway. That helped a lot. Right—Here the light worked pretty well, except for the highlight on the door frame.

detailed shadow and creates bright reflections. You can see the small, hard-light reflection on the door frame.

In the third shot (above left), I tried to use a 30-inch shoot-through umbrella outside. Umbrellas are bad in the wind. I changed to a larger umbrella later in the evolution of the shot and added a sand bag to keep the light from blowing over.

The light on the stairway and the floor were not bright enough, so I also added a light inside the doorway on the left side. When I took the shot, I thought this light created the reflection on the right side of the doorway (I hadn't noticed it earlier). Reflections can be hard to figure out. The tethering program on this camera doesn't allow you to back up quickly. This means it is really important to do a complete examination of the shot at each stage. I could have saved myself some time if I had sooner realized that it wasn't this new light that was causing the reflection.

The light on the second-floor landing did not illuminate the ceiling as evenly as I would like, so I moved the light back and shot another image. In this shot, (top right), the light in the hallway is a little bright. There isn't as much shape in the entry room because the light is even and

the shadow of the banister appears a little too intense.

One of the problems with making a shot is deciding when it is done. When do you say, "This is just what the client needs," and when do you decide to work a little longer? In this case, I knew that I could make the door frame better. I suppose that there are jobs where you could keep making minor changes forever. In most cases, I think it is important to take a few moments to really look at the shot. This is one of the reasons why tethering your camera to a laptop is so important. Without the larger image on the laptop, it is really hard to evaluate the image effectively.

In the image shown below, the light on the second-floor landing is nice and smooth. It really defines the shapes up there. I like the light in the

hallway now. One of the things it does is define the curve at the top of the hallway. This shot is all about curves, so keeping the lines strong is really important. I fixed the highlight on the door frame by changing the light modifier on the unit outside the door to a large umbrella. I used a 45-inch umbrella and added a sand bag on top of the stand to keep the light stable. The shot would have been easier if I had noticed that the outdoor light was causing the reflection sooner than I did.

As you can see, I also pulled the camera back a bit. For me, this was the change that made the shot. I really like the wood and the curve at the top of the photo. It creates a frame around the image. The shapes are good. There is a nice sense of openness that wasn't there in the beginning.

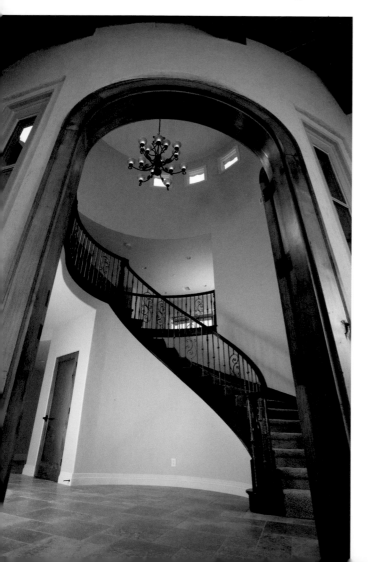

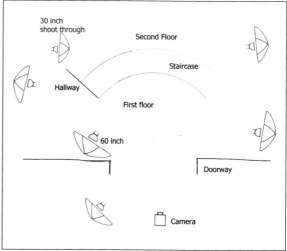

Left—Here is the final capture. The light is smooth, and the door frame looks great! Above—This diagram shows where the lights ended up. The umbrellas, except where noted, are 45-inch umbrellas. Except for the shoot-through unit on the second floor, all of the umbrellas have black backs. Facing page—This is the final shot after a color correction in Camera Raw and some minor work in Photoshop.

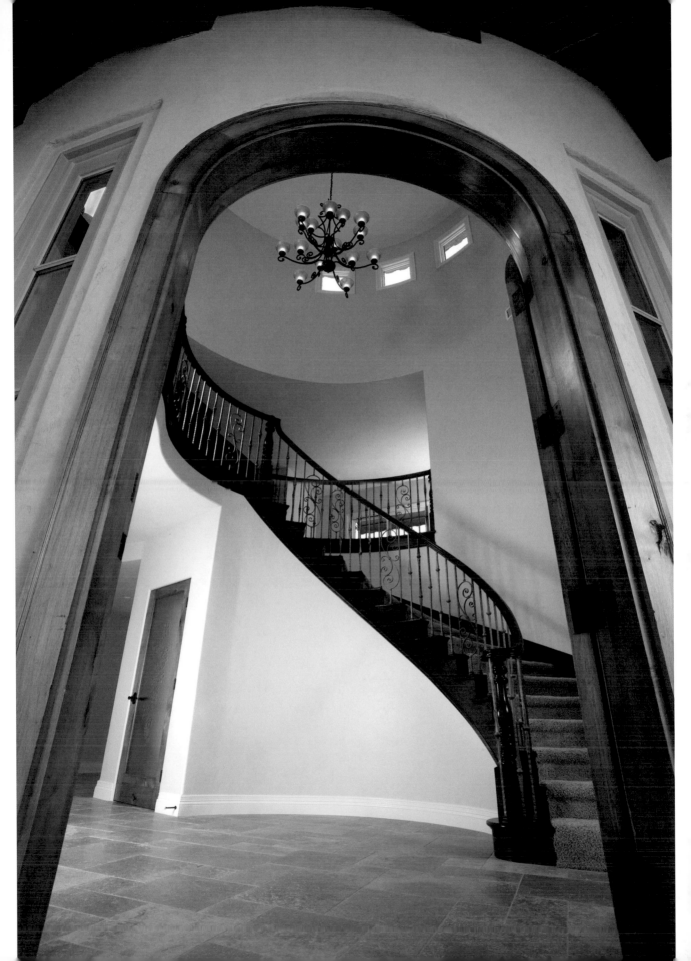

I also added a light at the top-left side of the shot, on the second floor. You can see a little bit of the light in the upper-left window. I added a light in a hallway at the bottom right of the shot. This light really didn't affect the shot very much, but it did seem to bring a little light to the banister.

Most of the lights were fitted with 45-inch umbrellas, but the umbrella inside the doorway was a 60-inch and the one on the top left of the landing was a 30-inch shoot-through. Except for the shoot-through umbrella, all the umbrellas had black backs, so they only lit the shot by reflection.

To create the final image (page 103), I had to do a little postproduction work. When I opened the image in Camera Raw, I used the Color Temperature slider to make the shot about 250K degrees warmer. I also brightened the exposure by about one third of a stop. In Photoshop, I used the Crop tool with the Perspective box checked. I pulled the top corners of the cropping box closer together to make the door frame stand up a little straighter. While I didn't feel it needed to be straightened completely, opening it up made the shot work better. I also cropped a little bit of the floor, because the change in perspective made the shot a little too narrow. I removed the power outlet and a few odds and ends from the second-floor ceiling. I didn't think they brought anything to the shot. I also put some density back into the window in the upper left.

Stone Creek

There were two real problems in photographing this room. First, the best position for the camera, in terms of the elements of the shot, created bad keystoning. Second, we had a lot of trouble getting the strobes to trigger at the same time.

There are basically two ways to sync multiple strobes: via optical or radio trigger. Optical triggers are small devices (usually without batteries) that plug into a strobe head or into a sync cord. When optical slaves are exposed to a quickly brightening light, they trigger the strobe that they're attached to. This means the light from another strobe will trigger a strobe on a slave. Many other things can also trigger them: reflections, caution lights, and so on. Another problem is that optical slaves won't see around corners or see a strobe at a distance.

Radio triggers can also be used to fire strobes. There are sometimes issues with distance and walls that will cause radio slaves to fail, but, especially with fresh batteries, they have far fewer limitations than optical slaves—so remember to carry extra batteries.

Radio slaves come with different levels of sensitivity. As you can imagine, devices with greater sensitivity are more expensive. In this case, I was using both radio slaves and optical slaves. Perhaps because of the dark floor and mid-toned walls, the optical slaves were only firing some of the time. I still use both optical and radio slaves, but I now have and use more radio slaves.

In the first version of the image, the light on the landing was clearly in the wrong place. There is no light in the dining room on the right. All of the light at the end of the hallway came from the window. Also, there is a bright spot next to the doorway in the center of the shot. Obviously, I was just throwing the lights around to get a first capture. Often I want to see an image on the laptop as soon as possible. Reviewing the image will make it easier to make more decisions. One more thing I noticed in this shot was the brightness of the windows.

BELOW—There were a lot of problems in the first capture.

Top—Here, the position of the light on the second floor is better. Also, there is more detail in the windows. Center—In this version of the image, there is more light in the room at the right and less light on the second floor. Bottom—The lights in the main room cast a more even light, and the hallway looks better.

The shutter speed used for the second image was a little shorter, so the windows appear a little less bright. There was supposed to be a strobe at the end of the hallway, but the optical trigger failed to fire the light. However, real progress was made with the light on the second-floor landing. The bright spot next to the hallway is still there. Whenever you have a flat wall with even color, you can face problems in keeping the light even. In this case, I used one light with a 60-inch umbrella to light the room, and it was not sufficiently even. Another problem is that the light created a shadow at the leading edge of the staircase. At this point in the process, there are always multiple problems in a difficult shot. When I shot with film, I tried to solve all the problems at once, because each Polaroid proof cost a few dollars. That doesn't sound like a lot, but over a year the Polaroid bill was more than $10,000. In shooting with digital, you can change things one at a time and see what happens at each step. Remember, everything you do affects the whole shot.

For the third version of the shot, I put a light in the dining room at the right. It was set to a low power—100 watt-seconds. It opened up the room a little without drawing the eye into the room (it wasn't the focal point of the shot). I also reduced the power of the light on the second-floor landing.

Things got better in the fourth version of the image. First, the wall at the center of the shot is

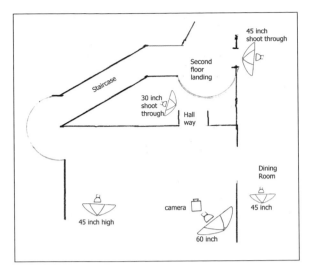

ABOVE—The light in the main room with the 60-inch umbrella is a monolight at 400 watt-seconds. Most of the rest of the lights were set at 200 watt-seconds.

more evenly lit. As you can tell from the position of the light stand, I moved the light near the camera. Also, the shadow at the edge of the stairway changed, and the result is much better. What may not be immediately apparent is that there is more light in the hallway, which helps to define the shapes. My assistant is barely visible at the end of the hall, checking the sync on the light in the far room. There was no joy on that sync!

The final capture is shown at the bottom right of the page. We never did get that strobe in the far room to work. There is always a chance you will run into some problems, so the key is to have backup gear and to keep going.

The diagram above shows how the lights were placed. The light in the far room is not depicted in the illustration, since it didn't work. The light in the hallway was a 30-inch umbrella placed in a closet. The final exposure was $^1/_{30}$ at f/11 and ISO 125.

TOP—The light stand was moved, and the light looks good. This is the final image I captured. BOTTOM—The color was warmed up and the shadows and highlights were adjusted.

All I did in Camera Raw was warm up the color a bit and use Fill Light and Recovery sliders to open up the shadows some and allow for more density in the windows. The Fill Light was set to 9 and Recovery was set to 17.

I was able to open up the far room a little in Photoshop, and the client was happy. You can also see that I got most of the light stand out of

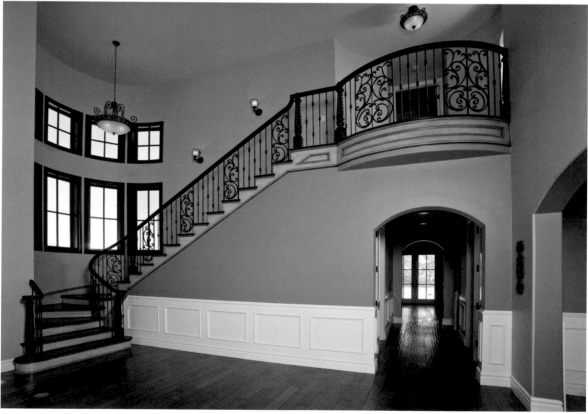

Top—This screen shot shows how the Crop tool was set. Bottom—I cleaned up some sensor dirt and removed a few wall plates. I also did a little minor sharpening. Digital cameras do require attention to detail.

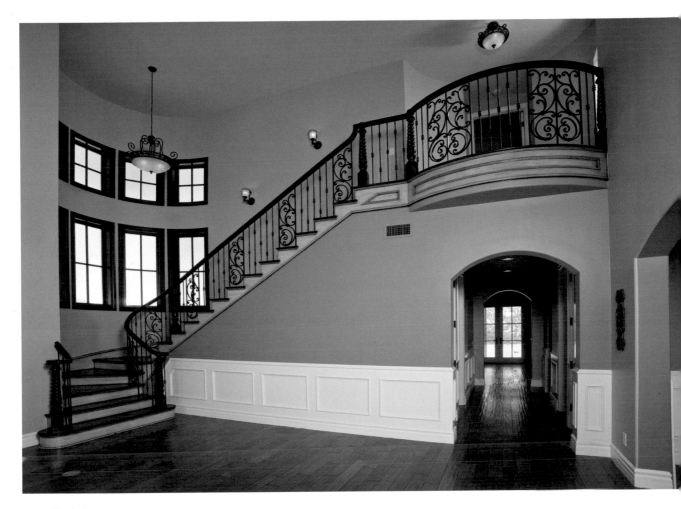

ABOVE—The final image.

the shot. I'm happy with the way the windows on the left and the second-floor landing turned out. They were fine features of the room. Finally, I did a bit of dodging and burning in the hallway. I think everything turned out well. I know the client was pleased.

The Crest

Shots in the bathroom are difficult. The space is generally small, and there are a number of reflective surfaces. So it is always a special plea-

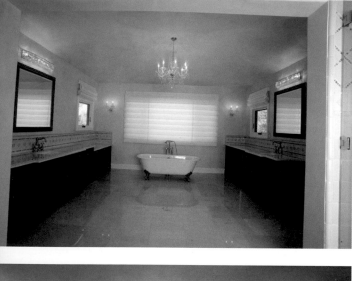

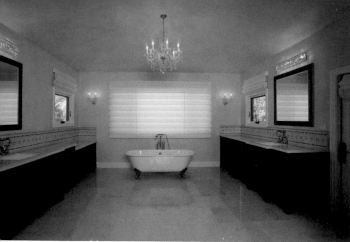

sure to be able to shoot in a bath that is really large. You still have reflective surfaces, but you also have more options for dealing with the problems. This was a really fun bath to shoot.

One of the things that made this shoot particularly great was the assistant. I am often lucky enough to often have assistants who are great photographers in their own right. Mike had a different approach for shooting this room. In the end, we did it both ways. He was really interested in a version with ambient light, and I preferred a shot made with strobes. I always think in terms of how to light a subject, even when I end up using ambient light as the primary light.

In this case, a 60-inch umbrella placed near the camera provided all the light I needed. Of course, this is usually the way I start, and sometimes finish. Although the light was okay, I didn't like the camera position. Not only was the camera tilted, but the doorway was also cutting into the cabinets.

I was not happy with the balance between my light and the ambient light in the first shot. I thought that more ambient light would be more attractive. Also, there were artifacts from my sen-

Top—The first capture with the strobe—a monolight at half power with a 60-inch umbrella. Bottom—Here, I've moved the camera and made the shutter speed a little longer.

sor in the image—primarily red dots on the light sources—which is often the case with my camera. Fortunately, there were no large reflection issues, and the color in the shot looked pretty good.

I re-shot the image. I decided to change the camera position and used a shutter speed that was one stop slower to get a brighter shot. The result is shown at the bottom of the facing page.

When I opened the shot in Camera Raw, I used the Color Temperature slider to make the image warmer. I used the Recovery slider to brighten the shadows and cabinets a little. As I generally do, I raised the Vibrance and Saturation levels slightly. You can see the results in the image at the top of this page.

I didn't have much to do in Photoshop. I cleaned up sensor dirt and the artifacts from the lights first, then did a little sharpening.

Top—I warmed up the color in Camera Raw and adjusted the Recovery slider. Bottom—The final shot. I used one strobe at 375 watt-seconds and a 60-inch umbrella. A long shutter speed of $^1/_{10}$ second was used with an f/9.5 aperture and an ISO setting of 100.

I really like the way the ambient light and the strobes worked together in this shot. The final image was made at f/9.5 and $^1/_{10}$ second, so you can see, because of the long exposure, how much of the ambient light I used. The light was a 750 watt-second monolight set to $^1/_2$ power. The brightness of the open windows on the sides of the shot and the window with the covering in the back creates a nice feel for the light.

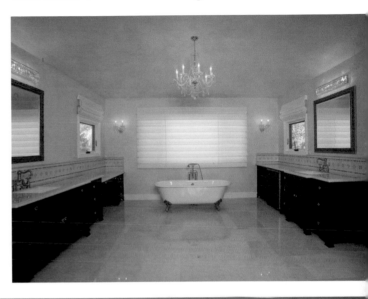

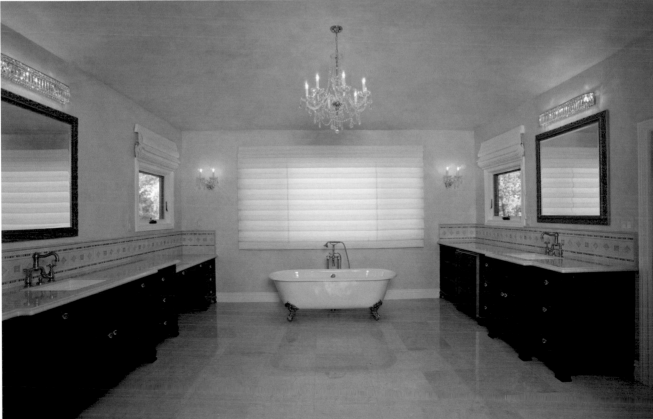

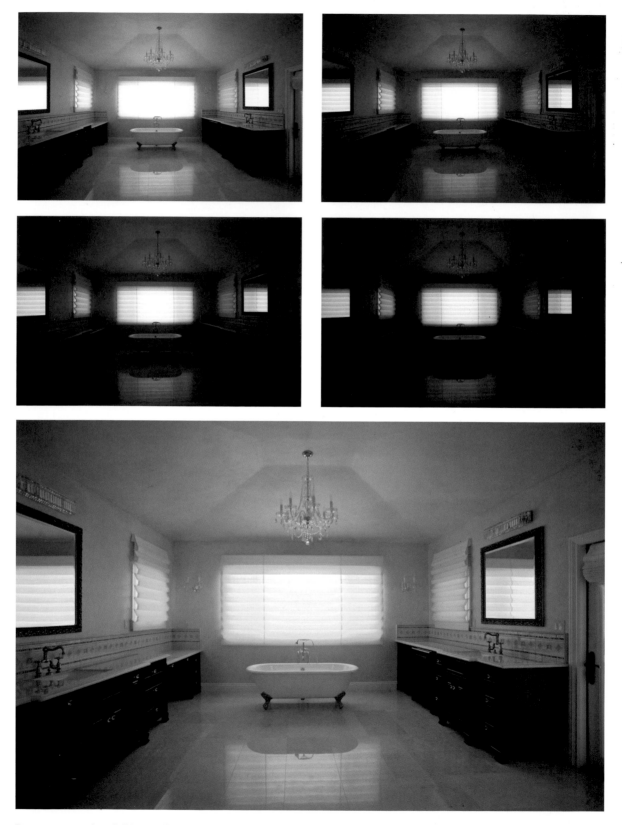

Top and center rows—I used all four versions of the shot to create an HDR image. Bottom—I don't like this version all that much. I could certainly fix the color, but the shot doesn't have much sparkle. I really don't like the way the windows work, and there was some movement in the chandelier.

Top—This is the bright version of the shot. Most of the final image comes from this version. Center—This dark image will give me the detail I need in the windows. Bottom—This version will give me the lights in the chandelier. You can see how much overall color the lights created in the ambient light version of the shot.

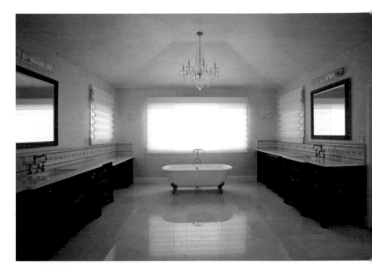

I made numerous shots without any lights on. I wanted to see what I could do with an HDR version of this shot. I ended up using four files (see facing page, top) for the HDR.

I used the Equalize Histogram to convert from 32-bit depth to 8-bit depth. When I used HDR with the RAW files, my color corrections disappeared. The resulting image is shown at the bottom of the facing page.

My assistant, Mike, wasn't thinking about using HDR. He wanted to use Layers to manually bring the different versions of the shot (shown on the right) together.

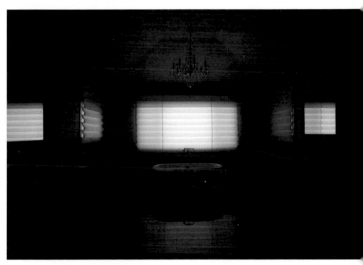

The brightest exposure (top) was used as the main layer of the shot. The dark image (center) was used to recover the windows. The image with the lit chandelier was used to put the lights back into the shot. I used the Recovery slider (in Camera Raw) on the bright layer to open the dark areas of the cabinets a little. I also adjusted the Vibrance and Saturation settings. I didn't need to change the overall exposure, as I had already warmed up the color on the light and dark files. I made the color of the file with the lit chandelier a little cooler. You can see how much the lights changed the overall color (bottom right).

I used the Eraser tool and chose a large, soft brush to pull detail back into the window. I worked on the center of the shot and the mirrors on the sides. I used a 500-pixel brush with an Opacity setting of 12 for the overall work. I also added just a little bit of density to the chandelier

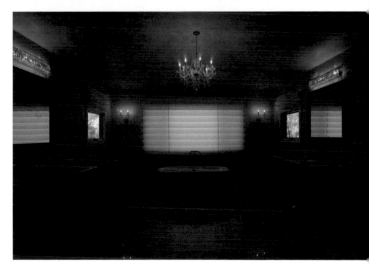

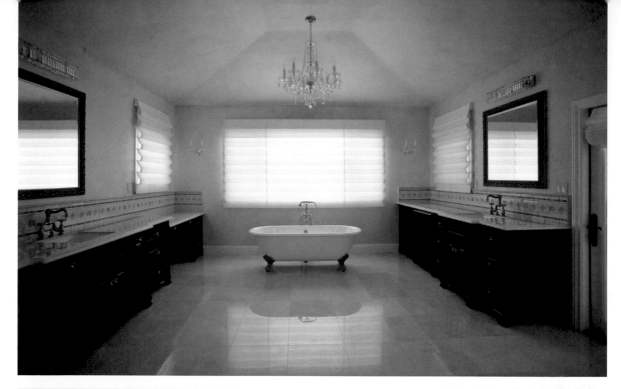

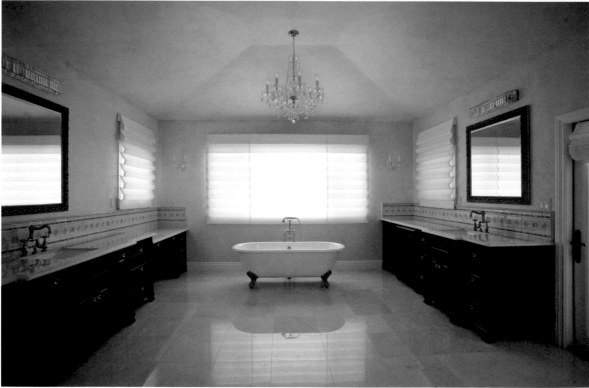

Top—I added a lot more detail to the back window and the mirrors in this shot. Bottom—Here I mixed in the file with the chandelier lit to add a little light to the center of the shot. Of course, I needed to clean up sensor dirt and do some straightening with the Crop tool. I also did a little sharpening in this last version.

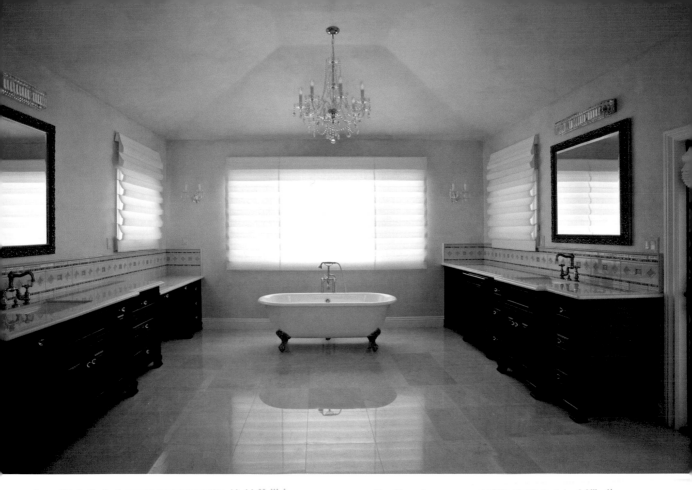

ABOVE—This is the final version, made with ambient light. Multiple exposures were combined to make every aspect of the shot look its best. I like the shot, but I prefer the image made with the strobes.

so there would be more contrast when I added the lights.

First, I did the bulbs on the chandelier. I used a much smaller brush for the bulbs. I also used more opacity: 20%. Then I chose a broad, soft brush and "painted" over the whole chandelier, at 5% opacity. The chandelier looked reasonable, but I prefer the way it looked in the image made with the strobes. Of course, all of this retouching is a mater of creating results that work for you and for your client. There are no actual rules. I could have pulled up the lights over the mirrors, but I didn't like the effect of these lights.

Overall, I like the version made with the strobes better. For one thing, the room looks brand new in that shot. Also, the reflection on the floor isn't as strong. I think the cabinets look better in the strobe image as well. I think that, in the strobe shot, the greater opacity in the back window makes the room seem more private, which is good for a bathroom. If I had a subject, such as a person, in the shot, the cooler version made with ambient light might have worked best.

Oaks

This room had a couple of nice features. There was a lot of the detail on the front of the island. There was some nice carving and a really great finish on the wood. The client wanted to

be sure these aspects of the room would show up in the shot. I liked the color of the walls in the room behind the kitchen, as I knew it would create good separation between the rooms. The view outside the window was not so good. The landscaping hasn't happened yet.

To create the first image (top left), I used only one light source, a large umbrella, which was placed behind the camera. You can see that I didn't use much power at all. There are a few reflections in the kitchen, but there was not nearly enough separation in that room. Also, there wasn't much detail on the front of the island. Still, considering that there wasn't much lighting, the shot looked pretty good.

For the second shot, I added a light on the left side. This light had a good deal of power, close to 750 watt-seconds. This softened the overall light and made it more even. I made the shutter speed a little longer and selected an aperture that was a half a stop larger. This made the windows brighter. Since nothing good was happening outdoors, this helped the shot quite a bit. I was a little worried about the light from the windows falling on the floor, but by the time I took the shot, it wasn't a problem.

Top—The first shot. The light isn't even, and the kitchen doesn't show much detail. Bottom—Adding a second light, opening the aperture, and increasing the shutter speed helped a lot.

Top—Here, the light in the back room is better. The rich color in the room was created by placing a filter over the strobe. Center—More lights were used at the edge of the kitchen, and a low light was placed to the left of the camera. The power was not yet set right. Bottom—The final capture. The balance looks good and the shot has good three-dimensionality.

I moved the camera a little for the third shot (top right). I opted to use a shoot-through umbrella to give me even light in the far room. I also put a ½ CTO filter over the strobe. This made the light a lot warmer. I think this gave more separation between the two rooms. I like the brightness. It makes the space look bigger.

Next, I added two lights. The first was a low shoot-through umbrella that opened up the detail on the front of the island. You can see this umbrella in the shot (right center image). I wanted a smaller, harder light to create some reflections. Reflections help to define the shape and color of the wood. I also added a light in the kitchen. The kitchen light was balanced on top of the stove, as there was not much room to work in. The balance between the lights wasn't working too well; the new lights were too bright. Also, the position of the kitchen light was not perfect. You can see why working tethered to the computer can be so valuable.

In the next shot (bottom right), things were back in balance! I went through several tests to get the light in the kitchen properly positioned. The problem is that I had to use a small umbrella because space was tight. I used a small light stand on the stove and a second shoot-through umbrella. I wanted some reflectivity in the tile to help define the finish. The light lent a greater sense of dimension to the cabinets. I think this works pretty well.

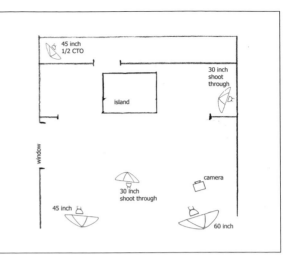

ABOVE—This diagram shows the final position of the lights and the camera.

I created a couple of versions of the shot, but the one shown at the top of the page is my favorite.

The above diagram shows the position of the lights. The 60-inch umbrella was finally set at about 400 watt-seconds, and the two shoot-through umbrellas were set at 100 watt-seconds. The other two umbrellas were at 200 watt-seconds. The last two lights—the low shoot-through in front and the light on the stove—were tricky to position.

I made two versions of the shot in Camera Raw. The first one (left center) was the important one. I moved the Fill Light slider to 12 and left the Recovery slider alone. I also left the color balance alone. I did increase the contrast a little. I also added 15 units of Vibrance and 10 units of Saturation.

I made a second version of the image (bottom left) that was one stop brighter. I wanted this file to help make the windows brighter and have less detail. I used Gaussian Blur to soften this version. There are a lot of ways to deal with

TOP—I made some little adjustments in Camera Raw for this version. CENTER—This brighter version of the image was used to clean up the windows. BOTTOM—I erased information from the normal version of the image to show data from the brighter version to make the windows work better.

a window, but I thought this would work for this shot. I could have selected the window and used Curves on just the window, but this seemed a better solution.

Next, I cropped the image and did some cleaning and sharpening. I used the Healing Brush to remove the fan blade from the upper corner of the room. This took several tries. I also dodged the front of the island a little.

I really like the way the island works in the final shot. The sense of shape and distance in the shot is also effective. The warm color in this shot comes from the light and paint, not the Color Temperature slider in Camera Raw that I use so often.

BELOW—The final version of the shot. The image was cropped and cleaned up. I did some dodging on the front of the island. Also, the windows are brighter and softer.

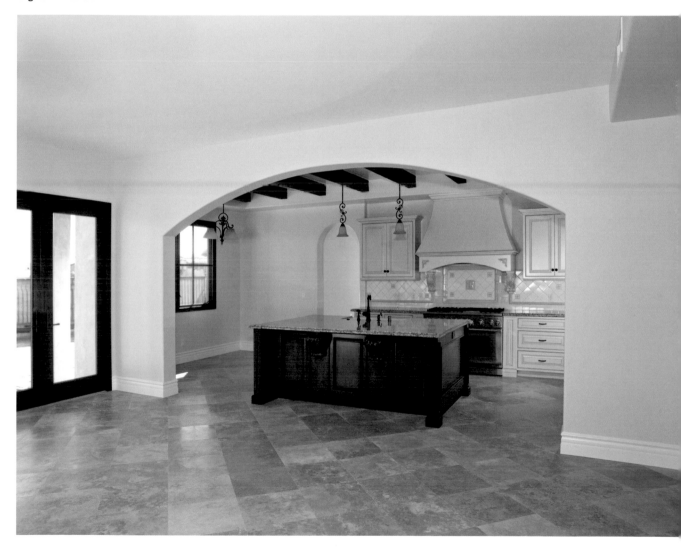

Magnavino

As soon as you add people to a shot, you add a large group of important variables. You have to worry about how the light affects the faces, and you have to worry about the subjects' expressions. You need to think about how the subjects are interacting with each other. And it all has to be right. Finally, I think every photographer, on some level, worries about what the subjects are thinking about him/her.

I shot this job for one of my oldest clients: Robert Wagner of the Wagner Creative Group. We've been working together for more than twenty years. He's owned a design firm all that time, and now he's opening a winery: Magnavino Cellars. We were doing quite a few shots on this day. I had seven images on my shot list, and he was doing a few outdoor shots himself. All of this meant that we had to keep moving. Also, we were using the same group of models for all the shots, and we didn't want them to look tired.

The top-left image is the first shot made that day, at midmorning. We were after a dinner-time look, as wine early in the day might not send the right message. So I wanted the daylight to be warm. I could have put a ½ CTO filter over the windows, but I hadn't brought rolls of the stuff with me. I put a ½ CTB filter over the strobes in the shot. Because I started with blue light,

Top—There are two strobes here, both with blue filtration, so the color is cold. Bottom—This exposure was too dark. I needed to open up the lens and increase the power of the strobe.

Top—The exposure and the balance of the light work well in this shot.
Bottom—The gray card with uncorrected color.

I would have to neutralize the blue in Camera Raw (i.e., remove blue from the shot). If I removed blue from the whole shot, the windows would be warmer. This is a really effective way to mix daylight and strobe with a digital camera and a RAW file. I used a 60-inch umbrella on camera left and a 45-inch umbrella to the right of the camera at the head of the table. Of course, the daylight added a lot of light to the shot also. If the room was the subject, I think I would have added one more light to make things a little softer. This light was good for the people.

When I got the people into the shot (facing page, bottom), it was clear that I needed to increase the exposure. I started with the shutter set at $^1/_{20}$, with an f/6.7 aperture and an ISO of 125. In this next shot (top right), I opened up the aperture to f/5.6 and increased the output on the monolight by one stop. The result was much better. This image was one of the keepers from my first edit.

Now that the quantity of the light was right, I needed to work with the color. I could have played with the Color Temperature slider in Camera Raw and found a good balance, but I wanted to be able to get a good color balance quickly on all the shots. So I took a version of the shot with a rather large gray card (right center). The size makes it easier to sample.

In Camera Raw, there is an Eyedropper tool that can be used to adjust the white balance. Use it in an area on the card that where there are no reflections. You don't want to balance for the reflection of the wine bottle, for instance. The color-balanced shot is shown here (bottom right).

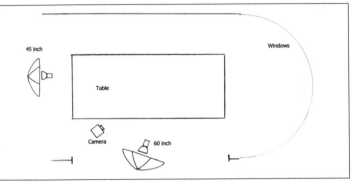

Top—I applied the new color balance to the earlier version of this image. It makes the shot work much better. Bottom—This diagram shows the position of the lights. Note that the strobes had blue filters.

Above, you can see the image with the proper color balance. Everything looks so much nicer with good color! I will probably want to make some minor color adjustments in the final image, but this is a quick way to get all the images in the ballpark. I prefer to balance color in the computer, either when tethered to the laptop or after the shot. It is hard to pick the right point for a color balance on the back of the camera.

The diagram shows what the lighting looked like. It was really pretty simple; just two strobes were used. You want to remember that much

of the light comes from the window and some comes from the fixture above. With a shutter speed of $\frac{1}{20}$, these lights are significant. I would have considered a longer shutter speed, but the people would have appeared blurry due to movement.

Now if this was a shot about the architecture, we could pack the gear and go on. But with people shots, you need to make a large number of image versions. I made over 140 shots. I made images with this arrangement of people, and with the people in different positions.

I'm going to show some of the postproduction work that went into my favorite version of the shot, and I'll provide a couple of alternate versions. When you work with a designer or an editor, you need to give them options. The shot at the top of the facing page shows the image as captured, with the color correction.

I used a Fill Light with a setting of 13, and I set the Recovery to 33. The color temperature seemed warm enough to me. I brought the Vibrance to 15 but I left the Saturation at zero. Neither setting did a lot at these low levels. Now the shot was a little lighter.

I cropped the image pretty tightly. After all, the wine is the reason for the shot. I also softened the shadow on the face on the left and reduced the highlight on the face on camera right. I cleaned up a couple of small reflections in the bottle. I was happy, and so was the client.

Top LEFT—Here is my favorite image, with just a color correction. Top RIGHT—In Camera Raw, I opened up the shadows and reduced the highlights. Bottom—I gave the client a copy of all the files that didn't have obvious issues, such as blinking models, poor expressions, or technical issues. The client received over 100 shots. Some clients want RAW files, and some want ones you worked on in Photoshop. The key is to discover what they want before you start. Here are a couple more versions of this shot that I liked.

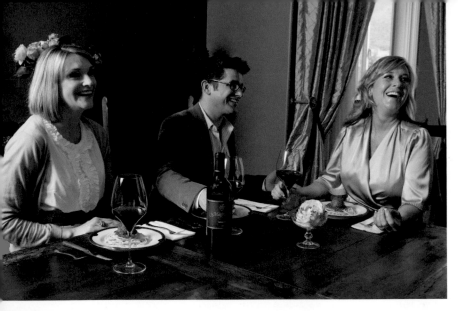

TOP—These are lifestyle shots. They are geared more toward selling the idea of the product than showing the product. The people do seem to be having fun. CENTER—I can't say why, but I don't like this arrangement of the people as well. However, it does make for a good alternative version of the shot. BOTTOM—Toasting a good day of shooting!

Warehouse

This was one of the last jobs I shot with film. One of the reasons I used film was that the shot ran as a two-page spread in a brochure, so it was 11x17 inches. This was a little large for the 6-megapixel camera I had at the time. It might have been okay if there was no cropping. So I made the shot with a 4x5-inch Toyo camera with a 90mm lens, which would have been a 24mm lens on a full-frame sensor or about 16mm on an APS-sized sensor. One thing to keep in mind

Below—This job was a real challenge, a big space with no useful ambient light. This is the shot with twelve lights in place.

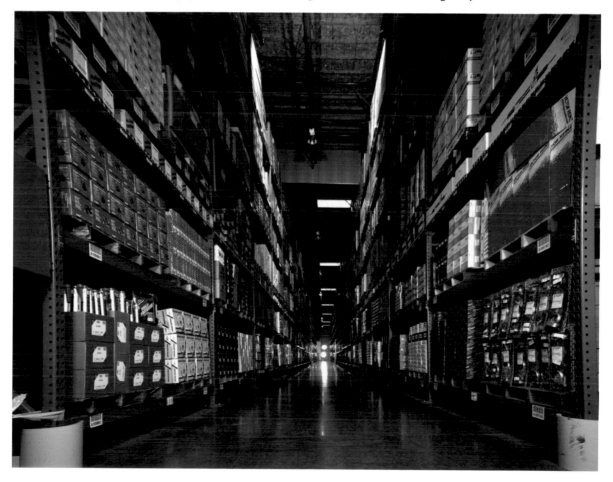

about the difference between large format film and digital is that with digital you need less light, but not fewer lights. Because the lens is shorter, you have enough depth of field at a wider aperture. In this case, I used f/16. I could have used f/8 with a digital camera. I would have needed ¼ the amount of light.

The job is harder with film—you need heavier lights and a heavier camera—but the real change is the information you get while making the shot. With digital, you have visual feedback every step of the way, especially if you are tethered to a laptop. Every time you want feedback with a 4x5 film camera, you have to load a piece of Polaroid film into the back of the camera and take a shot. Each piece of Polaroid costs about $4, so you want to make sure you learn as much as possible from each Polaroid. I would have shot at least twenty test shots with digital for a shoot like

this, so $80 for Polaroid. In this case, I only shot about three Polaroid tests. You have to think the shot through very carefully before you shoot. Of course, I also used a meter. Meters don't give nearly as much information as a histogram and the image on a laptop, but they are free to use.

I used twelve strobes in this shot but only two umbrellas. I was using lights with just the metal bowl reflectors for two reasons. First, I wanted to have hard light that would create a lot of contrast. The client sells auto parts, and I wanted to make it seem as though there are a really huge number of parts in this warehouse. I think I succeeded in that. Second, I needed all the power I could get. I needed to be at f/16, and I was lighting a huge area. If I had used umbrellas, I would not have had enough light. I was using ISO 100 film, and you can't change the ISO of film the way you can with digital.

Two of the strobes were placed on either side of the camera. Two more strobes were used at the top of the shot. I had to get on a forklift to mount these lights. You can see the light they emitted, and the actual units, at the top of the shot. There was a hallway about halfway down the aisle. I had three lights on each side of this opening. Two strobes were pointed away from the camera, and one faced the camera. The strobes illuminated the opposite side of the shot. If I had more powerful lights at this point, I would only have had two lights on each side of the hallway. As this was not the case, the additional pair of lights gave me more power. Finally, I stacked up a couple more lights with umbrellas

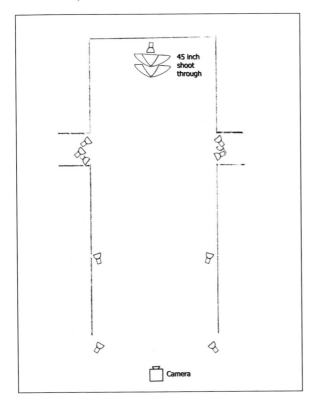

LEFT—The diagram shows where all twelve of the lights were placed. Obviously, it takes a while to place all those lights, especially with the ride on the forklift.

at the end of the hall. I used umbrellas here because I wanted to create a continuous reflection on the floor. This created a lot of separation at the back end of the shot. Of course, these lights had to be removed in Photoshop, but the reflection stayed. I used about 9000 watt-seconds of strobe power to make the shot. If any of the surfaces were white, I might have needed less light.

Of course, the job doesn't end when you push the shutter button, but when a dozen big strobes go off, you do feel as if you've done something.

I scanned the transparency and got the image shown here (top). One of the first things I needed to do was go into Photoshop's Distort menu and fix the pin-cushion distortion. With my lenses for my digital camera, I usually get barrel distortion. In this case, however, the lines

bowed inward, so I used a negative value to correct for the problem. I also used the Crop tool to straighten the left side of the shot. I cleaned up the dirt and did some sharpening. I also cloned out the umbrellas.

To create the third version of the image (bottom of the page), I cropped the shot to suit the dimensions of the two-page spread. This allowed

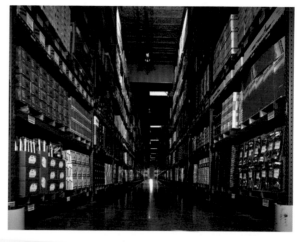

Top—Here is the image, cleaned up, sharpened, and with the umbrellas removed. Bottom—This is the way the shot was cropped in the brochure.

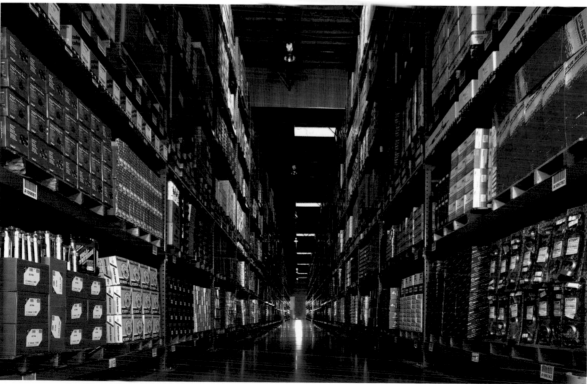

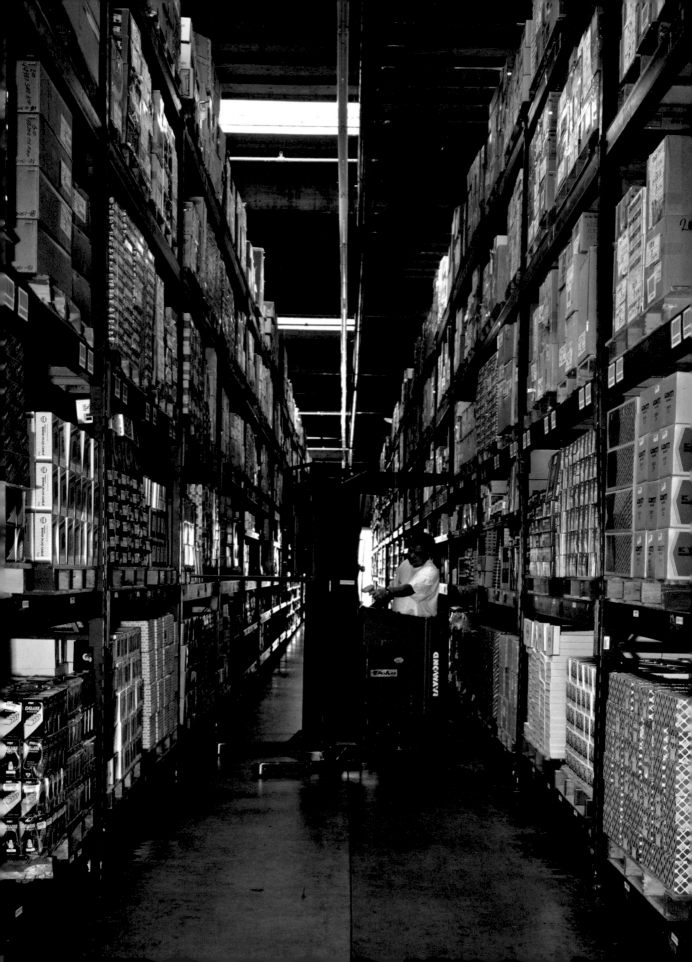

me to get rid of a lot of unfortunate things, like the lights at the top of shot. I also did a little dodging. I wanted to see the cropping before I made any adjustments. It makes it easier to get the balance in the shot right.

We did one more version of the shot while everything was set up. It adds a lot of value to a client to make alternate versions of the image, and it doesn't add much cost or time for the photographer. Building good relationships with clients is an important part of every shoot. When you're working, you still need to be concerned with the way your client sees you. I have known photographers who have had so much fun shooting that they lost their client!

FACING PAGE—Providing an alternate version of the shot can help to create a good relationship with the client. I really like this version of the image because the forklift helps to define the size of the warehouse, and the operator makes the shot more human.

Sound Studio

I wanted to include this job in the book because it was shot with continuous tungsten light. Sometimes, when you need to work with the light already in a room, using lights that have the about the same color as standard lightbulbs can be very effective. Most of the lights I used in this shot were 600-watt lights made by Smith-Victor. I also used gels to add color to the shot. The control room was very small, which made things somewhat difficult. I should also mention that I used film for this shot, so the camera was bigger.

BELOW—This is the version from the camera. Fixing the reflections was the most important remaining task.

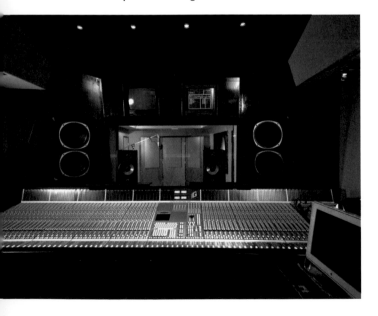

Quartz lights are smaller than strobes and they weigh less. They are close to the color of standard lightbulbs and halogen lights. So I like to use quartz anywhere that the existing light sources in the room are important to the mood of the shot. The problem with quartz is that when you mix it with daylight, either the daylight looks very blue or the quartz light looks yellow. While the human eye can correct for this, the camera can't. In order to get all the light to match in a shot, you have to filter it all to the same color. So if there was a window in this shot, I could put CTO filter material over the window to balance the color of the light. One other problem with quartz lights is that they are very hot. You can burn yourself just by touching the light fixture.

With strobes, when you want a light to act differently, to be tighter, for instance, you put a device like a snoot on the light. With quartz lights, you use an entirely different light fixture. Broad lights are used to light a large area smoothly. They were the most important lights in this shot and they worked well with the umbrellas I used. Spotlights create a very tight beam of light. Some spots have lenses to make them tighter. I refer to these as optical spots. I used two small optical spots in this shot. The broad lights were 600 watt-second lights, and the spots were 150 watt-second lights. Because I used the

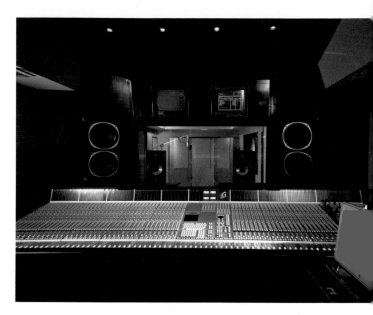

Top—Here's the shot after the glare was cleaned up with the Burn tool and the reflection on the monitor was fixed. Bottom—The umbrellas in the control room were set near the ceiling. The spots were set closer to the level of the control panel.

broad lights with umbrellas and the spots were used directly, they balanced pretty well.

For the first version of the shot, I used five lights. I placed a ribless 45-inch umbrella in each corner of the room. These lights were set high. Their placement caused some reflection in the wood panels above the windows. I also picked up a reflection in the monitor on the right. Two smaller spots, placed lower and closer to the control panel, were used to rake light across the control panel. The right-hand spotlight was modified with a magenta gel, and a blue gel was used on the spotlight on the left. These lights were placed to the right of the camera. Because there was so much light all over the room from the two umbrellas, the colored light from the gel-covered spots was washed out. I also placed a light in the room past the window. This was a single broad light with a 60-inch umbrella. Because I used a tungsten white balance, the lights in the ceiling and the spot on the right came out pretty white. If I had used a daylight balance, these light sources would have been more yellow.

There wasn't much to do in Photoshop. I cleaned up the glare on the wood and fixed the reflection in the monitor (I left some of the reflection to define the shapes). The exposure was about 1½ seconds at f/13. Obviously, the control board dominates this shot. This is a recording studio, so that makes sense. In a situation like this, showing the technology is as important as showing the space.

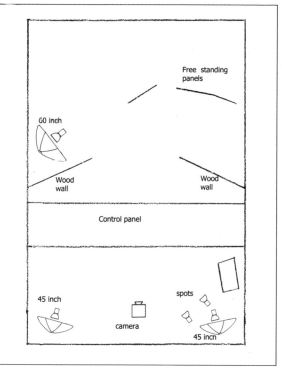

I shot another version of the image (shown on page 132), which made the control panel look more dramatic. I've shot a couple of recording studios, and the control panels are always important. I removed one of the 45-inch umbrella

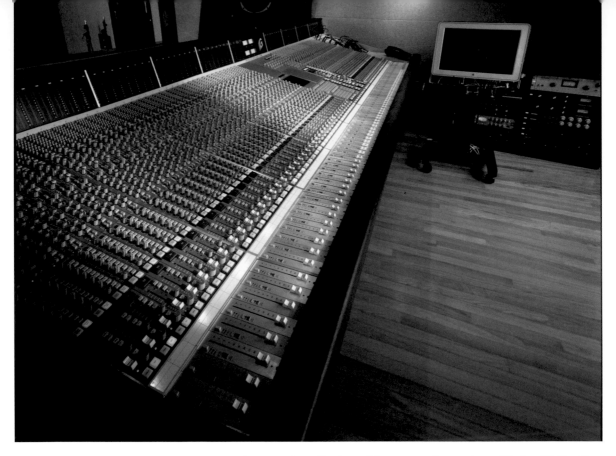

Free standing panels

60 inch

Wood wall

Wood wall

Control panel

camera

spots

45 inch

Top—I moved the camera and removed one of the broad lights with an umbrella. The shot is more dramatic and the color is more saturated. Bottom—In this diagram you can see how little the change was between these two shots. One light was removed and the camera was moved.

lights in the control room, which made the light on the control panel more dramatic. You can also see how much more saturated the color is. Having two umbrellas in the shot really washed out the color. Note that the actual light from the room's fixtures, on the far wall, became an important part of the shot.

In keeping with the more dramatic feel of this shot, I changed the perspective in Photoshop. With the Perspective box checked, I moved the lower left-hand corner of the cropping marquee inward. This allowed me to make the front of the shot even broader. I also increased the Saturation to 30. This made the shot a bit more dramatic.

One more thing: because I used a long exposure when making the shot, you can see the lights in the control board are on. The client liked that.

I don't use quartz lights often, but I really do like them when it is important to maintain the feel of the light in a room. I've used them for restaurant shots on a number of occasions. They maintain the warm feel of a restaurant, especially at night. Since you can use a long exposure, a 600 watt-second light can illuminate a very large area. Just remember to bring an extra bulb if you're going to use quartz lights.

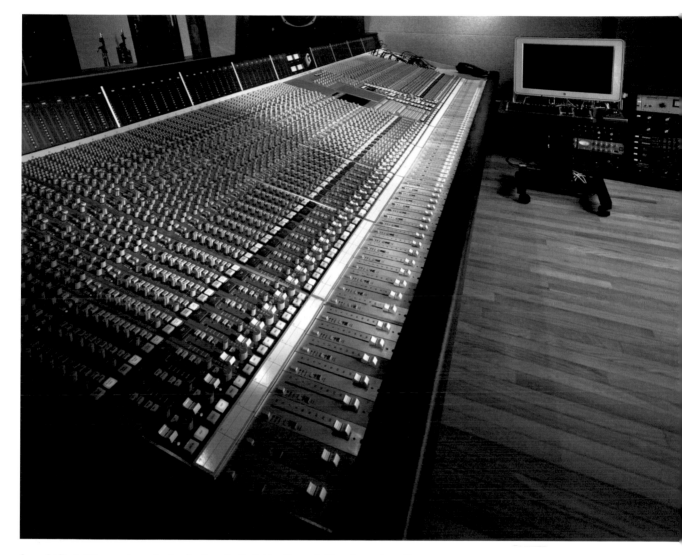

ABOVE—I adjusted the cropping and saturation to make the light on the control board more dramatic.

Night Shot

I don't often shoot nighttime exterior shots. Doing so is quite difficult, and it takes a long time. Also, obviously, the shoot has to be done in the evening. All of these factors tend to make this kind of shot expensive for the client. In addition, a night shot often doesn't show anything about the house that you can't see during the day.

The subject of this shoot is located in a remarkable setting. It is quite isolated. So the client thought that a night shot would make the place seem even more private, since you wouldn't be able to see any light other than that from the house. We also did a twilight shot that shows some of the setting (below). This is how the house looked just after sundown. The light inside was pretty yellow, but it made the house stand out nicely.

It didn't take long for the light to leave the sky, but while that was happening, I was putting up strobes.

I don't know when I first heard "light falls off inversely to the square of the distance." I still don't know what that means. I know how light is reduced by distance, but the English words

Below—A twilight shot. You can see how isolated the home is—and you can see there wasn't much landscaping yet. The night shot hid this.

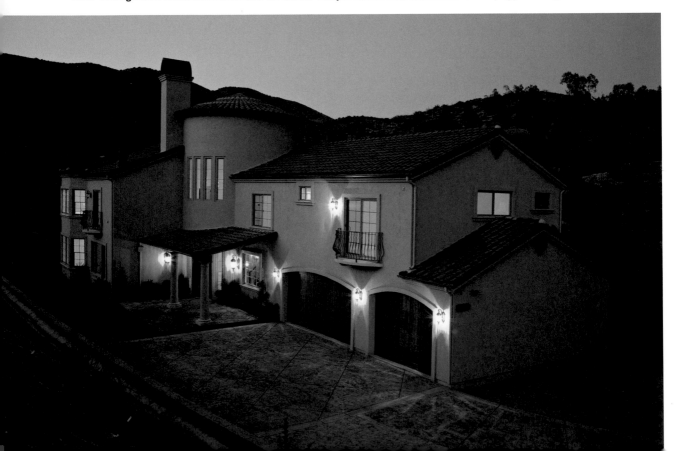

don't make any sense to me. The physics is not that difficult. When light leaves a bulb, it leaves in all directions. It disperses as a sphere, and the area covered gets larger very quickly. In practice, falloff works like decreasing your aperture. For instance, if you measure the light at 8 feet, then you'll have $\frac{1}{2}$ as much light at 11 feet and a $\frac{1}{4}$ of your original light at 16 feet. At 22 feet, you'll have just $\frac{1}{8}$ of your light left. The point of this is that lights at a distance from a building don't produce as much light as units placed close to the building. So, for this shot, I used my big studio strobes with just the metal bowl reflectors. I didn't have enough light to use umbrellas. Umbrellas wouldn't have made much difference at this distance anyway.

In addition to my studio strobes, I used a couple of other pieces of equipment that I don't get to use very often. I used Walkie-Talkies (you don't want to scream at your assistant from the other side of a house, even if you are isolated). I also got to use a generator. I like generators better than batteries because you can keep filling them with gas. A generator will run all night. You can run several monolights off a small generator quite easily. However, if you want to use studio strobes, which take quite a bit of power, you will need several generators, one big generator, or a Magic Bus. I almost hate to mention the bus, because they aren't made anymore, but if you are going to work with a generator frequently, you might want to search for a Magic Bus. What the bus does is to fill the strobes with power one after another, sequentially, rather than all at the same time. This reduces your power needs significantly, since strobes take a lot of power only just after they go off. One more thing you'll need on a job like this is a lot of extension cords.

ABOVE—The strobe on the left side of the shot didn't fire. Also, the overall exposure wasn't bright enough.

One thing that didn't work very well was the flash triggers. I was using mostly optical slaves at this point, and I thought they would do okay in the dark. I spent considerable time arranging the slaves so that they fired the packs. I use more radio triggers now.

The image had good shape when the lights were finally working. However, when the image above was shot, the lights at the left side weren't working and the exposure was not bright enough. You can see how little definition there is on the left side of the shot. One of the keys to the shot is to use the light to define the shape.

I checked the sync setup. I also brought a light that had been on the far side and around the front of the house. One of the great challenges of commercial photography, and of shooting interiors in particular, is getting all the lights, the camera, and other elements to work together.

Everything came together perfectly for the next version of the shot (following page, top). The exposure was f/9.8, $\frac{1}{5}$ second, and ISO 400. In retrospect, I should have tried one

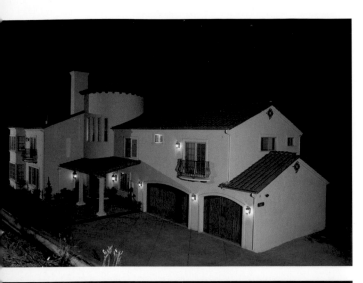

Top—Everything worked in this capture. I moved one of the lights to open up the left side of the shot. Center—Here is the final capture of the shot. In Camera Raw, I increased the Fill Light and Saturation settings. Bottom—I dodged the roof and cleaned up some details of the shot.

version with a much longer exposure, but with the lights turned off. I could have used this as an additional layer in Photoshop.

In Camera Raw, I brought up the Fill Light to a level of 15 to open up the shadows. One of the important elements in this shot is the roof, and I thought the Fill Light adjustment helped. I also set the Saturation level to 15. Here's the final capture of the shot (left center).

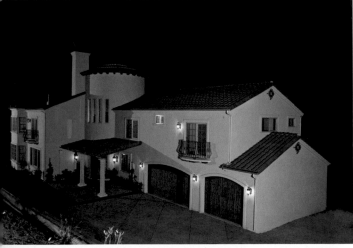

I used only four lights, but all of them were set at high power. I had three lights set at 2000 watt-seconds each, and one at 1250 watt-seconds, so I had a total of 7250 watt-seconds of light. The lights were strung in a row along the front of the house. The closest light was at least 20 feet from the front of the house. Compare this to an interior shot, where I might use four lights totaling 1300 watt-seconds. In this case, the shot was about power.

I did some dodging in the image, particularly to the roof (bottom-left image). I also used the Unsharp Mask to increase the contrast and sharpness. I cleaned up the dirt on the right of the shot and a few details on the house, like the floodlight on the side of the house.

Next, I made another version of the image in Camera Raw. I wanted to create an image with a much bluer color balance (facing page, top left), then use that file to make the house lights in the working image look a little less yellow.

Finally, I stacked the two versions of the image and used the Eraser tool to correct for the

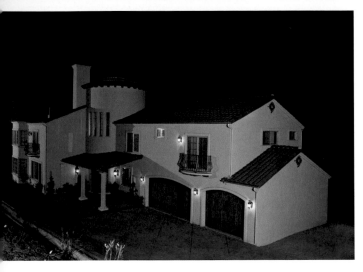

too-yellow light. I think the color in this image looked much better at this point (top right).

I cloned in a little bit of landscaping and darkened the left corner. The final thing I did was a little cropping. I like the dramatic look of the final image, which is shown at the bottom of the page.

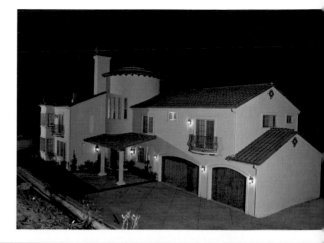

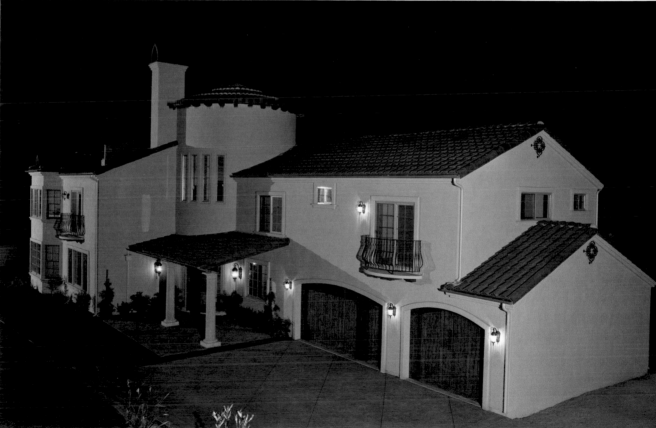

Top Left—Here is the tungsten-balanced version of the shot. Top Right—The combined version has more neutral lighting on the building. Above—The final version. A little cropping was done, and the lower-left corner was improved.

Big Wave Dave

I take a lot of photos that document construction. My clients use these images to validate

their businesses and capabilities for their clients. Often, people worry about contractors who won't show up or will do poor work. If a contractor can show a lot of shots from multiple jobs, their business will look reliable. One of my clients, Terry Beeler and Son, has thousands of construction images on their site: www.beeler buildsembetter.com.

Construction images are similar to event photography; you have to move through the location without interfering with the experience. Of course, with construction, you also need to worry about what might fall on your head!

This kind of work should be done with a camera-mounted strobe. When working in large areas, without much ambient light, a powerful strobe is important. In such cases, I often use a shoe cover on the strobe to keep the light spreading in all directions. The bounce light helps to fill in the shadows. I lose some of the light when using the shoe cover, but it solves more problems than it causes. Plus, it is very easy to remove. I also use a long shutter speed so that whatever light is in the shot will show up in the capture. Since most of the light is from the door and windows—in other words, it is daylight—the color generally matches well. If I was shooting at

LEFT—In this shot, I used the strobe to direct light onto the front of the subject.

LEFT—I increased the saturation and the contrast slightly in Camera Raw. RIGHT—I cropped the image carefully. I wanted to keep the right side and bottom of the shot. I also sharpened the image and cleaned up the mark on the subject's forehead.

night, I would probably put a CTO or a ½ CTO filter over the strobe.

In the first shot (facing page), made under an overhang, there was a lot of daylight. If I had not used the strobe, the subject would have been backlit and silhouetted.

The second image (above left) is the result of setting the Saturation to 10 and the Contrast to 15 in Camera Raw. I often change the color temperature to warm up my subjects, but I didn't need to do that here. The light that was bounced from all the warm-colored wood ensured that the shot would have a rich, warm color.

I wanted to crop the image to straighten the framing elements. This was tricky because I cropped the image tightly when I composed the shot and I wanted to retain as much of the subject's hand and foot as possible. I think it worked out well (above right).

For the next shot (shown on the following page), I worked with the same subject, but indoors. There was much less ambient light to work with. I used a shutter speed of ¹⁄₂₀ second to give me as much light from the door in the background as possible. Also I wanted to make this shot more dramatic, so I made the perspec-

LEFT—This shot works well, but I did want to use Camera Raw's Fill Light and Recovery sliders to tweak the image. I set the Recovery pretty high, to 45. This helped maintain the detail in the wood and managed the highlight on the subject's forehead. I only needed to set the Fill Light to 8 to open up the shadows. I didn't do anything with the other controls. I left the cropping alone on this shot, as I think it helps to exaggerate the perspective. The name of the saw is visible. I like that. RIGHT—I adjusted this shot using the Recovery and Fill Light sliders in Camera Raw.

tive more extreme by working with a very wide lens. I was actually standing very close to the power saw.

On the facing page, you can see one more version of this shot. The perspective is not as exaggerated, so I don't think it is as effective. This shot needed a lot more fill light, as I used a faster shutter speed.

When photographing people at an event or in another situation, keep your eyes open for interesting photographic opportunities and shoot a lot! Work with a variety of settings. Some of the shots may not be perfect, but it is part of a photographer's job to do editing and postproduction. It is part of how you control how people will see you.

The final photo in this section is one of those "extra" images. I like this image, as it seems as if the two painters are in sync.

Construction photography truly presents some wonderful opportunities for making great images.

LEFT—This shot was made from a little farther back, so the perspective is not as extreme. RIGHT—Here's a shot of the synchronized painters.

Hotel

There are a lot of times when the problems with a job have nothing to do with the photography. In this case, the designer was an hour

late, and then the owner of the hotel left to look for the perfect flower arrangement for the job. My assistant and I did nothing for about three hours. As I've mentioned, it is very important to specify the details of the shoot. In this case, there was a start time 9:00AM, but I guess the designer and owner didn't understand that. One of the reasons why I included this shoot is to remind you to be very clear about the schedule. I have had clients cancel on the day of a shoot, then act surprised when I billed them for the shoot. As photographers, we sell our time, and a late cancellation means I can't sell the time to anyone else. Still, if a regular client has a real problem, I will work something out.

In this case, the day got worse, but this shoot turned out well. Hotel rooms are small. The more rooms you can put in a building, the more money you can make. Because the rooms are so small, it is difficult to find good places for the camera and the lights. And, of course, the clients want to see everything and to make the room look larger. These clients didn't understand that perspective issues would be fixed in Photoshop after the shoot, so I used a Nikon 28mm

Top—This is the first version of the shot. There are several little issues but no big problems. Bottom—The lamps are on and the camera was moved slightly.

Top—Since there were several people working as art directors for this shot, a lot of small changes were made. Center—I opened up the lens and went to a longer shutter speed, so the shot is brighter, with more ambient light. Bottom—The final capture. I went back to the shorter shutter speed but kept the wider aperture. The shot is brighter, but the table lamps and the window lights are not as bright as the last shot.

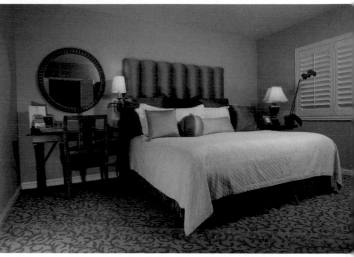

perspective-control lens. This lens moves in relation to the sensor, so you can shoot up or down with minimal or no keystoning. In this case, the camera was positioned at about eye level. The lens was moved instead of pointing the camera down.

I started with two lights: one near the camera and one in the upper-right corner of the room. Because of the size of the room, they were both pretty small. The light on camera right was a 45-inch umbrella pushed as far back into the corner as I could get it. The other light was on a small light stand right at the floor. The light is even in the first shot (facing page, top), but, because of the small umbrellas, there is some shadowing.

For the second shot (facing page, bottom) we turned on the table lamps and slightly adjusted the camera position. This made the bed more dominant. Look at the corner of the bed nearest the camera. There was considerable discussion about the way this should look. Attention to the small details of a shot is very important. The power of the strobe near the ceiling was reduced slightly also.

Next, the camera was moved back a little. Changes were made to the position of the window shutters. The light was about the same. The result is shown in the third image (top right).

For the fourth shot (center right), a wider aperture and a longer shutter speed were used.

Another light was added at the side of the camera; it was placed in the bathroom. There are still shadows, but they were opened up by the other

lights. Although the desk area seems a little fussy, the overall look of the shot is very good.

For the final capture (below), I used a shorter shutter speed to make the window shutters and lamps in the room appear slightly darker. The stuff on the desk was removed, and a floral arrangement was brought in. The overall exposure is very effective. You'll also notice that the perspective on this shot is pretty good. If the client wasn't there, I would have used a wider angle lens and fixed the keystoning in Photoshop after the shoot.

The diagram below shows the position of the lights. The real problem, which caused the shadows, was the small size of the light modifiers. If a 60-inch umbrella had fit in the room, it would have helped a lot.

In Camera Raw, I set the Fill Light to 20 and moved the Recovery slider to 5. I increased the Contrast setting slightly and moved the Vibrance slider to 14. I left the color balance alone, as the room was nicely warm in the capture.

To create the final version of the image (facing page), I sharpened a little and cleaned up the sensor dirt. I also dodged a few of the shadows. I cropped a little, then used the perspective control on the right side of the image.

Top—I used more **Fill Light** and **Vibrance** than any other adjustments when I changed the file in Camera Raw. Bottom—Three lights were used for this shot. On camera right, the light was near the ceiling. On camera left, the lights were set lower.

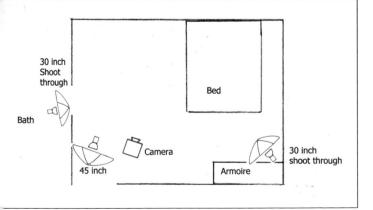

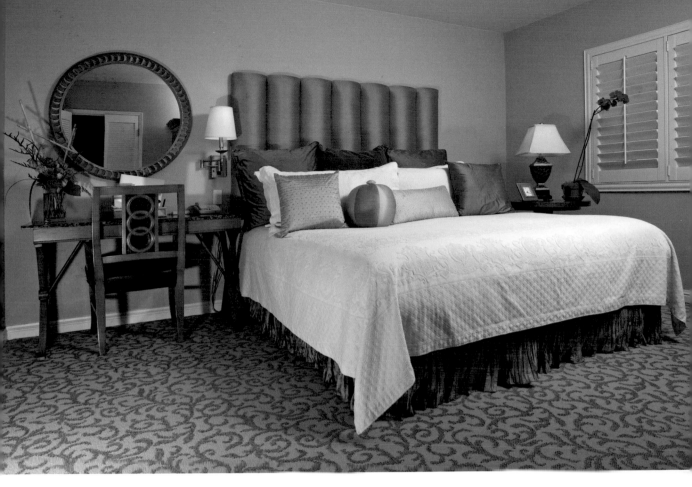

ABOVE—Dodging, sharpening, and cropping were the finishing touches for this shot.

Cathedral of Our Lady of the Angels

Photographers shoot public spaces for a variety of reasons, both personal and commercial. One of the first things to remember is that the public often has only limited rights to access the buildings, even when they are public buildings. So, if you want to shoot a wedding portrait on Pasadena City Hall grounds, you have to make an appointment and pay a fee. If you are talking about a privately owned building, your rights can be even more limited. I wanted to make a photograph of the Cathedral of Our Lady of the Angels here in Los Angeles. Dozens of tourists came in while I shot and snapped pictures. I needed special permission—first, because I wanted to use a tripod; second, because I wanted to publish the photographs; and third, because I wanted help from the staff. It seems that for every space in Los Angeles, there is someone who makes decisions about access for photography. The staff at the Cathedral was particularly kind and helpful.

I had been to the Cathedral before, so I was aware of the long tonal scale inside the building. I thought this would be a perfect place to use HDR capture. Of course, I would need a tripod to do this, so my first step was to go to the Cathedral's web site and find out who to contact. When I got to the facility, the staff was ready. I didn't even have to explain myself to the guards!

One of the most unusual features of the cathedral is that it doesn't have glass windows. Instead, it was built with large sheets of translucent alabaster to let in light. I wanted to maintain some detail in these sheets so that their unusual character would be apparent. I was able to shoot images with and without the lights in the facility. The image I provided to the Cathedral is one that was made with the lights on, but I did make a successful version without the lights on as well. I could have done something with strobes, but that would have interfered with the worshippers' use of the space.

Once I found an angle I liked, it was not difficult to set up the tripod and the camera. I used the camera meter to make a shot. As I was using a wide angle lens, I found that an aperture of f/6.7 provided enough depth of field. The shutter speed was $1/4$ second. I made additional shots at shutter speeds of 1 second and $1/2$, $1/8$, and $1/15$ second, giving me a five-stop range. The series of images is shown on the facing page.

When I opened the shot in Camera Raw, I realized that some color adjustments were needed. However, if I had adjusted the color in Camera Raw, the corrections would have been lost when I used the RAW files to make a Photoshop HDR. My version of Photoshop does not utilize the RAW file's "sidecar" info when making an HDR.

Above—I shot a six-stop range of exposures. I used Camera Raw to convert each image into a 16-bit depth TIFF file.

I converted the files into 16-bit TIFF files after making the same color correction on each file. Then, in Photoshop, I went to File>Automate>Merge to HDR and chose the six files. I had the computer align the image files. Even with a tripod, it is hard to shoot in perfect register unless you are triggering the camera remotely.

Fortunately, Photoshop does a good job of getting the images in register when you click on Automatically Align Source Images. In Photoshop's HDR dialog box, I adjusted the white point to make the shot substantially darker. If I hadn't done this, there wouldn't have been any detail in the alabaster windows. I set the bit depth to

Left—I used the adjustments to preserve some detail in the alabaster windows. Center—I like the shape better in this shot. I used the Crop tool to reduce the keystoning. Right—I brightened the midtones in Curves, then used the Dodge tool to brighten the organ and some of the altar. I think the effect added drama to the shot. Facing page—This is the final image. I think it worked very well!

8 and pressed OK. I could have converted to 16-bit depth and made more adjustments to the midtones, but I thought they worked well at this point.

When you convert the shot from a 32-bit depth to an 8- or 16-bit depth, Photoshop opens another dialog box. In Photoshop's next HDR dialog box, I adjusted the Exposure slider to make the shot darker. As before, one of the key points of the shot, for me, was ensuring there was detail in the bright windows. I also reduced the Gamma a little. This deepened the shadows, creating a longer tonal range. I was more interested in maintaining a dramatic light than in being able to see into all the shadows. I planned to use Curves and the Dodge and Burn tools later in the process, so this correction was for overall tonal range.

I adjusted the cropping to reduce the keystoning somewhat. I didn't want to remove the effect entirely, because it adds to the feeling of height. I also lifted up the right corner of the crop marquee to bring the left side of the shot down slightly.

Next I used the Curves control to make the midtones brighter. Sometimes it is very difficult to make a decision about where to set the curves. I went a little dark so that I could use the Dodge tool more effectively. I dodged the chair on the left, the cross, and the organ pipes. At this point, I was happy with the tonal balance.

Finally, I sharpened the image and eliminated some sensor problems.

I could have made this image with strobes, but because the room was so large, I would have needed a lot of big strobes. It is unlikely that

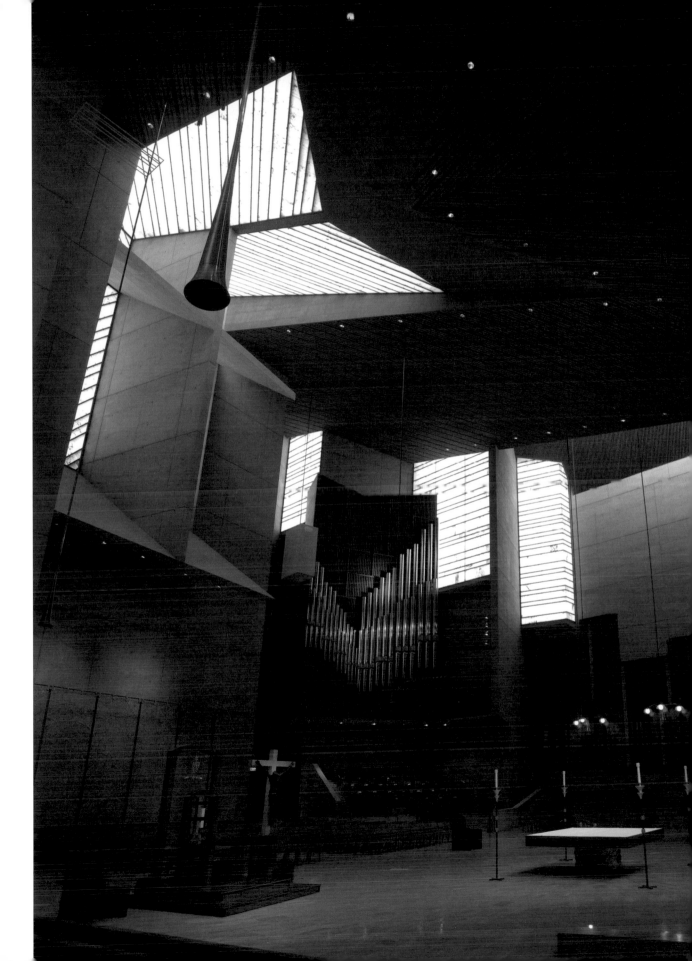

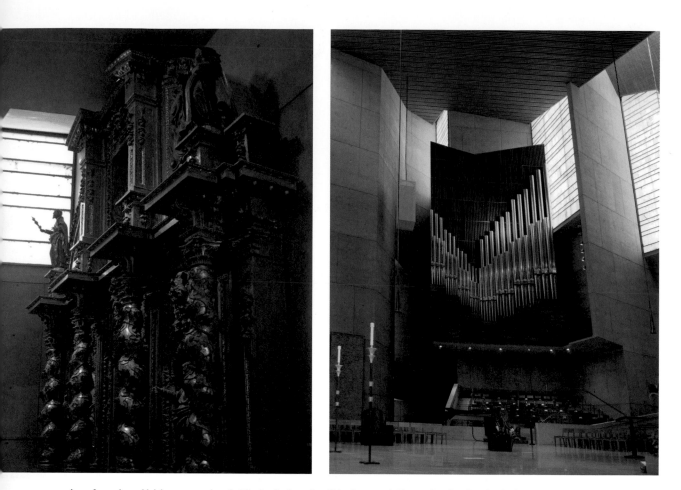

LEFT—A reredos, which is a screen placed at the back of an altar. This piece was in the previous Los Angeles Cathedral. I liked the challenge of using an HDR image to hold the details of the piece against the alabaster window. RIGHT—Here is a more direct look at the altar and the organ.

I could have gotten approval for such a job. Making several captures with ambient light is much less intrusive than using strobes!

I made a couple of other shots while I was at the cathedral. The sense of light in the sanctuary is extremely engaging. It is a very beautiful and peaceful place.

Canyon Exterior

This house had an unusual setting: it was the only one in a subdivision, and it was located across from some very interesting mountains. The first time I shot the house was late in the day, after shooting interiors all day. The original shot had a couple of problems; the biggest one was that the landscaping wasn't finished. I knew this was going to be the case—in fact, I had already arranged with my client to come back. The house was in a canyon, so there was little afternoon sun. Also, because the light came just from the sky, the color was very cool.

When I came back just a couple of weeks later, the place magically had grass and a few more plants. Sod, pre-grown grass, is inexpensive. I have occasionally picked up a few pieces on the way to a shot that wasn't landscaped. You can put it into the shot, then use a few pieces to create a whole background. You can even use sod as the background for a product shot.

I showed up just after the sun cleared the mountains. You can see, in the shot at the top of the following page, how the sun raking across the front of the building created more shape in the building. If the light on a building is too flat, the

Top—I tried to find shooting angles that showed less of the landscape
Bottom—Of course, I shot the exteriors because the client wanted to put something on the web site immediately.

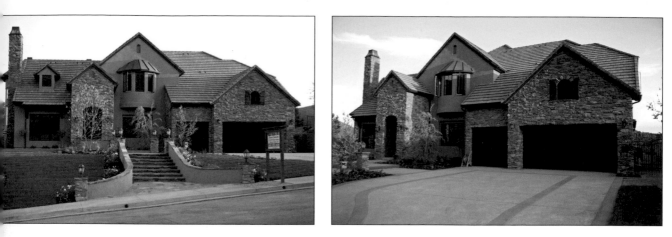

Left—Because there were no other homes in the subdivision, I could use a lot of different angles when shooting the home. In an area that is built up, you may want to avoid climbing onto another person's property. In the next shot, I got closer to the property. Right—As I moved closer to the house, and to the right side of home (from the camera position), the image became more three-dimensional. This image shows much more of the driveway and less of the landscaping.

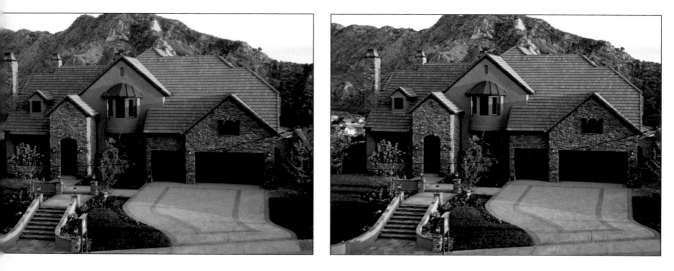

Left—The best angle was from across the street. There was an empty lot that was higher than the house. The view from there included the mountains behind the house. This shot required a little longer focal length than most of the architectural images I shoot—about 65mm. Right—I haven't found a magic button in Photoshop for removing power lines, which was the most pressing correction needed for this shot. There are a number of situations in which the Healing Brush works well, but not here. The Clone Stamp seemed the best bet for this job. The one thing you want to do is stop frequently and hit Save. If you keep going until you hit a problem, you will lose everything you did. In a situation like this, I stop about every inch. I also adjusted the color and perspective in this image.

three-dimensional quality of the structure can be lost. When sunlight is your only light source, you have to show up when the sunlight is coming in from the right direction. You can also see how much better the color is, without correction, in this shot.

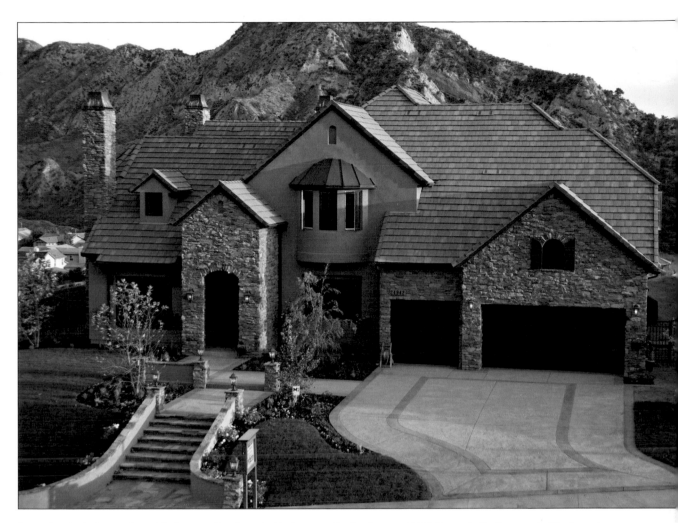

ABOVE—Shooting in the morning and finding a good angle made this shot very effective. However, I think the most effective aspect of the image is the site. When you shoot exteriors, you need to be concerned about light and perspective, as with an interior, but you often have to be present at the right time of day to get the best -possible image.

Conclusion

I hope that you've been inspired by this book, but what I really hope is that you'll go out and shoot.

There are two important challenges you should undertake to improve your skills. The first is to find public places in which you can shoot. Doing so will give you the opportunity to prac-

tice picking good locations, and you will have images to work on in Photoshop.

The second challenge is to practice with your strobes and learn how to bring out the noteworthy aspects of the interiors you shoot. If you don't have strobes, pick some up; remember, they can be used for more than just architectural

Below—Grand Central Station in New York City. The long exposure turned the moving people into ghosts. I like the effect.

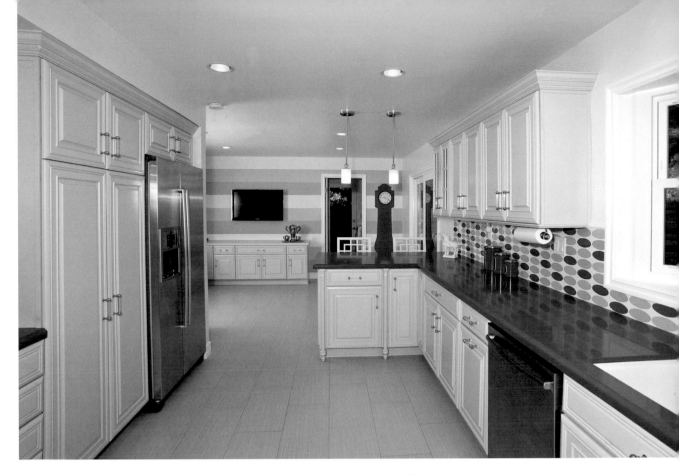

ABOVE—This shot was done for a cabinetmaker. I only used two strobes: one on the camera and another in the far room.

jobs. I use the same lights that I shoot buildings with for portraits and product shots. I use these lights when I work for architects, contractors, and also for annual reports for banks. Strobes are the most flexible lights that a photographer can get.

In the classes I teach, I ask people to shoot kitchens. This is because there are more shapes and levels of reflectivity in the kitchen than in any other room. If you can shoot a good kitchen shot, you'll be able to work in many other rooms. When you can shoot kitchens effectively, see if you can do a good shoot in the bath. This may require getting into some unusual positions. Kitchens and baths offer the most challenges, particularly with regard to reflections. Challenge can be a very effective teacher.

I wish you many fine photographs!

Index

OTHER BOOKS FROM

Amherst Media®

Understanding and Controlling Strobe Lighting

John Siskin shows you how to use and modify a single strobe, balance lights, perfect exposure, and more. *$34.95 list, 8.5x11, 128p, 150 color images, 20 diagrams, index, order no. 1927.*

500 Poses for Photographing Men

Michelle Perkins showcases an array of head-and-shoulders, three-quarter, full-length, and seated and standing poses. *$34.95 list, 8.5x11, 128p, 500 color images, order no. 1934.*

Off-Camera Flash

TECHNIQUES FOR DIGITAL PHOTOGRAPHERS

Neil van Niekerk shows you how to set your camera, choose the right settings, and position your flash for exceptional results. *$34.95 list, 8.5x11, 128p, 235 color images, index, order no. 1935.*

Family Photography

Christie Mumm shows you how to build a business based on client relationships and capture life-cycle milestones, from births, to senior portraits, to weddings. *$34.95 list, 8.5x11, 128p, 220 color images, index, order no. 1941.*

Flash and Ambient Lighting

FOR DIGITAL WEDDING PHOTOGRAPHY

Mark Chen shows you how to master the use of flash and ambient lighting for outstanding wedding images. *$34.95 list, 8.5x11, 128p, 200 color photos and diagrams, index, order no. 1942.*

500 Poses for Photographing Couples

Michelle Perkins showcases an array of poses that will give you the creative boost you need to create an evocative, meaningful portrait. *$34.95 list, 8.5x11, 128p, 500 color images, order no. 1943.*

Posing for Portrait Photography

A HEAD-TO-TOE GUIDE FOR DIGITAL PHOTOGRAPHERS, 2ND ED.

Jeff Smith shows you how to correct common figure flaws and create natural-looking poses. *$34.95 list, 8.5x11, 128p, 200 color images, index, order no. 1944.*

CHRISTOPHER GREY'S
Vintage Lighting

Re-create portrait styles popular from 1910 to 1970 or tweak the setups to create modern images with an edge. *$34.95 list, 8.5x11, 128p, 185 color images, 15 diagrams, index, order no. 1945.*

Engagement Portraiture

Learn how to create masterful engagement portraits and build a marketing and sales approach that maximizes profits. *$34.95 list, 8.5x11, 128p, 200 color images, index, order no. 1946.*

Lighting Essentials

Don Giannatti's subject-centric approach to lighting will teach you how to make confident lighting choices and flawlessly execute images that match your creative vision. *$34.95 list, 8.5x11, 128p, 240 color images, index, order no. 1947.*

Commercial Photography Handbook

Kirk Tuck shows you how to identify, market to, and satisfy your target markets—and maximize profits. *$34.95 list, 8.5x11, 128p, 110 color images, index, order no. 1890.*

THE PHOTOGRAPHER'S GUIDE TO MAKING MONEY
150 ideas for Cutting Costs and Boosting Profits

Karen Dórame provides surprising tips for cutting costs and boosting profits. *34.95 list, 8.5x11, 128p, 200 color images, index, order no. 1887.*

The Portrait Photographer's Guide to Posing, 2nd Ed.

Bill Hurter calls upon industry pros who show you the posing techniques that have taken them to the top. $34.95 list, 8.5x11, 128p, 250 color images, 5 diagrams, index, order no. 1949.

The Art of Off-Camera Flash Photography

Lou Jacobs Jr. provides a look at the lighting strategies of ten portrait and commercial lighting pros. *$34.95 list, 8.5x11, 128p, 180 color images, 30 diagrams, index, order no. 2008.*

Advanced Underwater Photography

Learn how to take your underwater photography to the next level and care for your equipment. *$34.95 list, 8.5x11, 128p, 225 color images, index, order no. 1951.*

Boutique Baby Photography

Create the ultimate portrait experience—from start to finish—for your higher-end baby and maternity portrait clients and watch your profits grow. *$34.95 list, 7.5x10, 160p, 200 color images, index, order no. 1952.*

Behind the Shutter

Salvatore Cincatta shares the business and marketing information you need to build a thriving wedding photography business. *$34.95 list, 7.5x10, 160p, 230 color images, index, order no. 1953.*

Master's Guide to Off-Camera Flash

Barry Staver presents basic principals of good lighting and shows you how to apply them with flash, both on and off the camera. $34.95 list, 7.5x10, 160p, 190 color images, index, order no. 1950.

CHRISTOPHER GREY'S
Lighting Techniques
FOR BEAUTY AND GLAMOUR PHOTOGRAPHY

Use twenty-six setups to create elegant and edgy lighting. *$34.95 list, 8.5x11, 128p, 170 color images, 30 diagrams, index, order no. 1924.*

Hollywood Lighting

Learn how to use hot lights to create dramatic, timeless Hollywood-style portraits that rival the masterworks of the 1930s and 1940s. *$34.95 list, 7.5x10, 160p, 148 color images, 130 diagrams, index, order no. 1956.*

500 Poses for Photographing High School Seniors

Michelle Perkins presents head-and-shoulders, three-quarter, full-length poses tailored to seniors' eclectic tastes. *$34.95 list, 8.5x11, 128p, 500 color images, order no. 1957.*

MORE PHOTO BOOKS ARE AVAILABLE

Amherst Media®
PO BOX 586
BUFFALO, NY 14226 USA

Individuals: If possible, purchase books from an Amherst Media retailer. To order directly, visit our web site, or call the toll-free number listed below to place your order. All major credit cards are accepted. *Dealers, distributors & colleges:* Write, call, or fax to place orders. For price information, contact Amherst Media or an Amherst Media sales representative. Net 30 days.

(800) 622-3278 or (716) 874-4450
Fax: (716) 874-4508

All prices, publication dates, and specifications are subject to change without notice.
Prices are in U.S. dollars. Payment in U.S. funds only.